IMAGES
of America

BOYS TOWN
THE CONSTANT SPIRIT

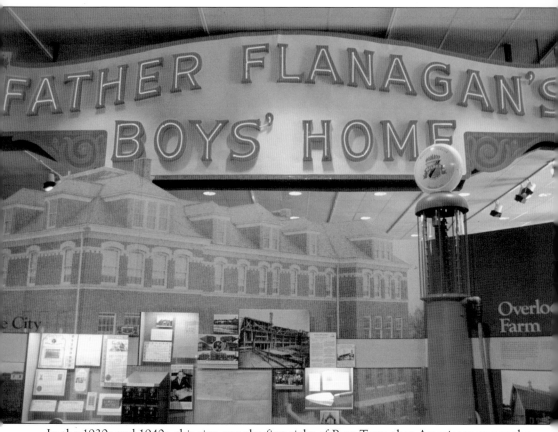

In the 1930s and 1940s, this sign was the first sight of Boys Town that Americans saw as they traveled the old Lincoln Highway. A large pylon replaced it about 1950. The old sign was found laying beside a barn at the home. It was restored, even the neon lights that once illuminated it, and now resides in the Hall of History.

IMAGES
of America

BOYS TOWN
THE CONSTANT SPIRIT

James R. Ivey

ARCADIA
PUBLISHING

Published by Arcadia Publishing
Charleston SC, Chicago IL, Portsmouth NH, San Francisco CA

Printed in the United States of America

Library of Congress Catalog Card Number: 00108396

For all general information contact Arcadia Publishing at:
Telephone 843-853-2070
Fax 843-853-0044
E-mail sales@arcadiapublishing.com
For customer service and orders:
Toll-Free 1-888-313-2665

Visit us on the Internet at www.arcadiapublishing.com

This book is dedicated to Al Witcofski, boy and man a part of Boys Town for more than 80 years. The inset photo shows Al a short time after his arrival at the home in 1919. He remained both as a boy and an employee for the remainder of his life.

Al Witcofski, 1912–2000

CONTENTS

ACKNOWLEDGMENTS

It would be raw conjecture to particularize what Omaha would be today without the evolution of Boys Town. Certainly, colorful shards and slices of its early 20th century history would be missing. Early Boys Town, NE, was remote from Omaha proper. But a devoted few, notably photographer Louis Bostwick, pierced that remoteness to give image to the ideas of Father Edward J. Flanagan. A deep bow to Bostwick and the Durham Western Heritage Museum, caretakers of his voluminous collection and to other early photography studios like Ernest Bihler and Walter Craig. The reference departments of the University of Nebraska at Omaha and the Omaha W. Dale Clark Library were invaluable in providing historical and socioeconomic backgrounds. The city library's fine microfilming of both daily and weekly newspapers back to early days were relied upon to verify stories that were only rumors in other records.

The little-known Henry J. Hess, who never saw Boys Town, should receive the gratitude of all graduates and officials. The wealthy Chicago man was an admirer and upon his death, left a sizable bequest to Boys Town, part of it going to the crafting of the Hall of History by director Tom Lynch. I have a deep sense of obligation to Tom and his volunteer staff who selflessly helped compile pictures and, what was more, so fastidiously over the years interviewed old grads for their early day experiences and to Stan Struble, alumni director. My deepest thanks to Boys Town's digital Everyman, Michael Bourg, and graphics designers and specialists Anne Hughes, Margie Brabec, Lisa Reeg, and Stacy Oltmans, who seemed genuinely downcast when I came to see them and had no pictures for reproduction.

INTRODUCTION

On Feb. 14, 1926, in their first election, the something less than 200 residents of Father Flanagan's Boys' Home, a new refuge for homeless and wayward boys, voted to change the name to Boys Town. The event was noted in the *Boys Home Journal.*

On Aug. 23, 2000, the more than 1,200 boys and girls of the Boys Town residential centers from coast to coast rolled back the years. For the second time in its history, the venerated child care organization changed its name, to Girls and Boys Town.

This time more than a dozen newspeople covered the event, and the news was flashed across the nation. Inquiries came from at least two foreign countries. At first, the news was confused. Just what had changed? What Father Edward J. Flanagan had started with borrowed money in December 1917, was now so large, so complex, so many-faced. The name Girls and Boys Town applied to so much: the 1,200 boys and girls in long-term residences in nine facilities from New York City to Los Angeles; the 33,000 getting direct care through its services, shelters and research and care hospital; and 250,000 more receiving information and help through the Boys Town National Hotline.

This photographic journal will course the viewer through time travel from that single home with its first five occupants in 1917 to the broad tableau of contributing satellites that represent the Girls and Boys Town of the 21st century. More than that, it goes through the looking glass to the colorful days, to times that were different for Americans, perhaps so much easier, slower, less perplexing.

When old Boys Towners began their reunions in 1951, how they must have howled as long-forgotten stories surfaced—being stranded for 10 days with a horse-and-wagon in southern Nebraska, the guy trying to make black Oscar Flakes eat in the kitchen, and Father E.J. marching everybody out, sleeping in chicken coops in the new home, hauling irrigation water by buckets during the Dust Bowl of the '30s.

He never scuffled a foot in the sawdust trail nor bawled out a line for the imprimaturs of salvation and redemption in a half-acre tent—but Father Flanagan was an evangelist. His song was about brotherhood, love, understanding, and giving every American kid a chance for a childhood. It became a seal on the hearts of thousands.

So the reader may understand the response of a Boys Town alum who returned to watch the day of the election. He also talked with some Boys Town grade schoolers. They asked how he wanted the elections to come out. It doesn't matter, he replied.

"To you and I, it will always be Boys Town, anyway," he said.

One

THE EARLY YEARS

A Chance Meeting on a Trolley and

the Birth of an American Institution

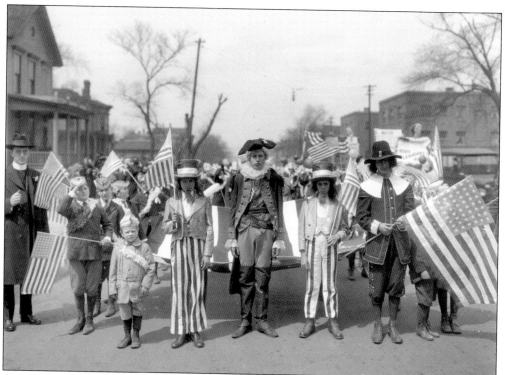

Tiny Father Flanagan's Boys' Home, in time to become Boys Town, joined in the patriotic fervor that swept America during and after World War I. With a hard-tack budget, the home made its own costumes and appeared in nearly every parade in Omaha. In return—and partly out of curiosity of what the home was doing—residents thronged to watch them. These boys were a colorful part of a post-war parade in 1920.

DEALING WITH "THE BOY PROBLEM"

In this day of voice identification and electronic security, the skeleton key has become a thing of the past. But 80 years ago, the instrument commonly called a pass key was guarded jealously: it would open many doors. A young woman literally and figuratively supplied the key to the future for a priest and millions of young Americans during a meeting on a trolley car in Omaha, NE, in November 1917.

It would be short-minded to think that if the woman, the priest, and an undertaker had not met that bleak November day, there would have been no Father Flanagan's Boys' Home and hence no Boys Town. The Rev. Edward J. Flanagan was consumed by too much driving compassion not to do what he did with the last 30 years of his life.

Cate Dannehy, born Catherine Shields, a real estate agent, was drawn into the conversation of the mortician, Leo A. Hoffmann, and Father Flanagan, late of County Roscommon, Ireland, and O'Neill, NE.-The priest had a problem. He had five homeless boys from off the streets. He had no place to keep them. The clergyman was already known about Omaha; he had been operating a free boarding house for unemployed men.

Cate Dannehy fished around her purse and drew out a skeleton key. It was-for a large home at 25th and Dodge Streets, at the edge of the downtown area, owned by a prominent real estate man, she said. Her company wasn't listing it but she was showing it. Would Father be interested in looking at it? He was.

It fit his needs. The priest borrowed the $90 for monthly rent, probably from attorney Henry Monsky, and by Dec. 12, 1917, Father Flanagan's Boys' Home was a factor, however nebulous, on the city streets.

Mortician Hoffmann was to direct some of the early fund drives by the home.-Cate Dannehy worked briefly for the home in 1918 and 1919. In 1930, she came back to work permanently for Father Flanagan, retiring in 1958. At her retirement, she said she didn't recall how many times she had seen Father Flanagan take his insurance policy to a local bank as security for another loan to face down hard times. A hard-pan road confronted the home and much of it was through the economic sloughs of the Great Depression.

As the Boys Home and later Boys Town, it never was to achieve any sort of financial balance until more than 20 years later, when Father Flanagan was finally able to establish-his long sought trust fund in 1941.

Omaha of World War I was an ethnic goulash of Americans who were-African American, Polish, Bohemian, German, Irish, Greek, Italian, Danish, Norwegian, Mexican, Greek, and

Chinese. The city was moving west, away from the river. The demographic jockeying left behind a healthy industrious-inner city, the majority working hard for their pay, commingled with a core working as hard to relieve them of it:-gamblers, crooked and otherwise, thieves, pickpockets, strong-arm thugs, swindlers, and bootleggers.

Into this milieu, roads and railroads daily dumped a new supply of wandering men and boys. This had prompted the priest, Father Flanagan, to open his Workingmens' Hotel in the railroad district in 1915. He quickly saw the flaw. Most of these men were too far gone to help. Judges, police, his friend Henry Monsky, also a juvenile court probation officer, all advised him to try to care for the young delinquent boys wandering the streets. Although Monsky was Jewish and the priest Catholic, they shared the feeling that faith, education, and kindness could provide the spark to change a young life.

Omaha Archbishop Jeremiah Harty, who had helped establish the hotel, relieved Father Flanagan of parish duties to concentrate on the mission of finding and establishing a home. Flanagan borrowed the $90 to secure the home Cate Dannehy held for him. Two School Sisters of Notre Dame came to help. With the five boys, they moved in Dec. 12, 1917. Christmas fare that first year was sauerkraut and potatoes, all donated.

It was winter and many said with fair weather, the boys would be on the road again. But by spring, the home had more than 100 residents. Larger quarters were needed.-By June 1918, again with donor money, they were in the abandoned German-American Home in southern Omaha.

Those were colorful years. To get the story out, the priest and the boys appeared everywhere.-They danced, sang, recited, appeared as clowns and Pilgrims, carried flowers, wore uniforms. Still the residency grew.

With a great deal of finagling and fund-raising, Father Flanagan attracted enough money to start the purchase of a large tract 10 miles west of Omaha, called Overlook Farm.

He now had his dream, his plan.

The home would be open to all boys of all races, creeds, colors, and nationalities. How a boy worshiped would be his business, but there would be worship. There would be education, and the training to show a boy how to make his way in the world. Finally, there would be the fortifying bond of self determination.

On October 22, 1921, Father Flanagan's Boys' Home moved to Overlook Farm.

The first five boys were in the home Dec. 12, 1917. The boys shown above are thought to be the first, although the records are not clear. Three were sent by courts, two by police. By Christmas 1917, more than 20 were in what was called Father Flanagan's Boys' Home.

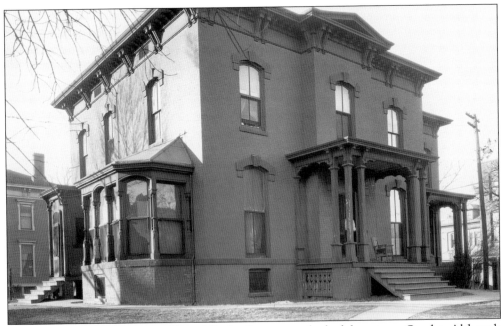

The first Boys Town home at 25th and Dodge Streets overlooked downtown Omaha. Although it is accepted as true but wasn't verified, Father Flanagan borrowed the $90 from Jewish attorney Henry Monsky, a great Flanagan admirer, to take over the building. Furnishings were donated by backers of all religious faiths and on Sunday, boys were taken to the church of choice. The origin of the early ecumenical traditions, this was praised by many but suspected among hard-liners. Years later, an insurance building replaced the home.

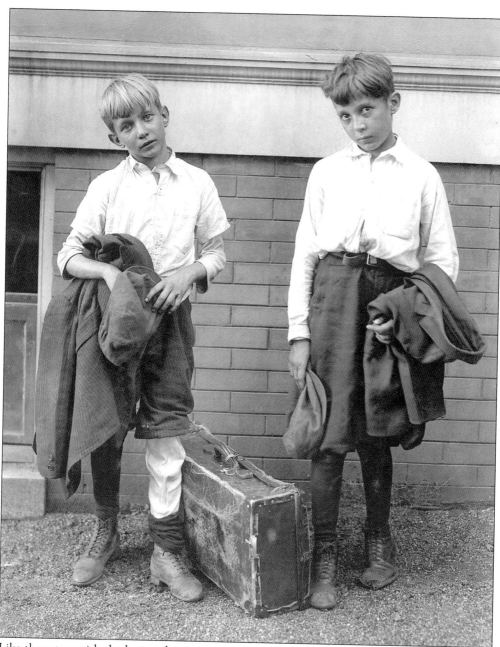

Like these two with the battered suitcase, the boys usually arrived with threadbare uncertainty. In the early days, many of the boys actually walked into the home. In the 1930s, one boy's journey to Boys Town started in a jail in Idaho.

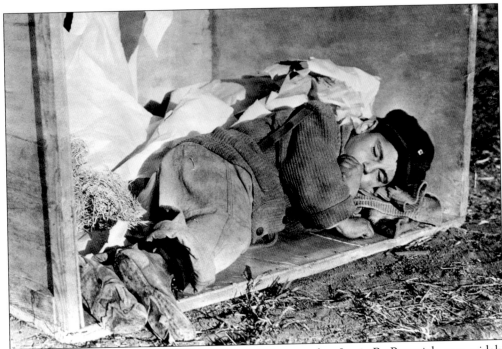

The boy in a box, snapped by famous Omaha photographer Louis R. Bostwick, was widely reproduced in the early days. Bostwick, who had lived in Chicago and New York City, was aware of social problems of the day. He became a Flanagan admirer and photographically recorded the early days of the development of a Boys Town.

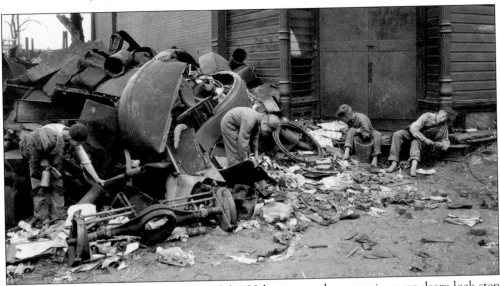

Part of the "boy problem" at the dawn of the 20th century, they were in compulsory lock step with the Industrial Revolution. They found themselves fettered to the age, sleeping in its cast-off containers and hogsheads. Here shown picking over a rubbish pile, they were called "Street Arabs" by photographer Jacob Riis, who shocked New Yorkers when he depicted life in its "Hells Kitchen". Riis, an immigrant himself, was shocked by the waste of young lives in the affluent young country. *Jacob Riis Collection, Museum of the City of New York.*

Bostwick presented a stark background of this youth who wandered into the home from the farm belt. The young who roamed the small towns and farms were called hoe boys because of the tools they often carried—the derivative of this century's later appellation, the hobo. At this time, about half of the population of the U.S. lived on farms or in farm areas.

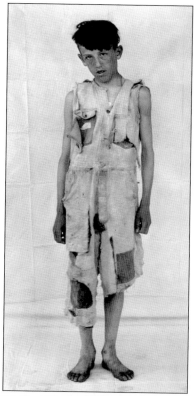

Riis pictured the young homeless where he found them, sprawled here in a sub-street level in Manhattan. His graphic examination of the problem was biting satire: "How the Other Half Lives." In a single year at the turn of the century, 522 youngsters died in New York City institutions, more than 5,800 were picked up wandering the streets, and 2,700 were described as sick and destitute. Despite the large number rounded up, the army of Riis' "Street Arabs" grew. *Jacob Riis Collection, Museum of the City of New York.*

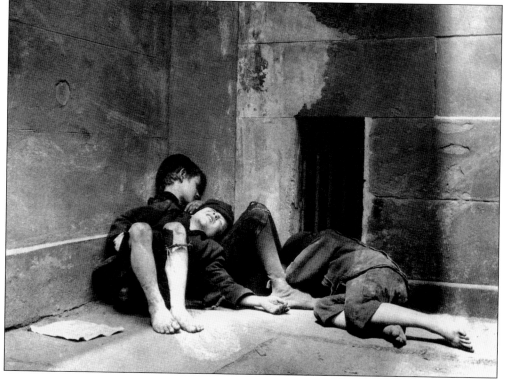

BOYS, 7 AND 9, CRIMINALS IN EYES OF LAW

Held in Reformatory; Priest Offers Them Home, but Sees No Way of Releasing Them

OMAHA, March 24.—Two little boys, one 7 and one 9, who are confined in the Missouri State Reformatory, at Boonville, Mo., as "criminals," are the subject of a tilt between Governor S. A. Baker, of Missouri, and the Rev. E. J. Flanagan, of Omaha, head of Father Flanagan's Boys' Home.

Father Flanagan asks that the two boys, only 7 and 9 years, be declared not criminals at heart and that they be released. ...

L.A. CITIZENS AROUSED OVER ROAMING BOYS

Leaders Meet Tonight to Find Way to Aid Wandering Youths

What is wandering Los Ange... What that pit aimless daily city rou...

HUNGRY CHILDREN STORM CITY HALL

Besiege Offi... After Char... ve Out...

...Racing cials w...

7.—Heeding knocking for food... sidered ...

BOY, 6, TRIED AS KILLER OF PLAYMATE, 8

Headlines reflected the shock Americans felt over the uprooting that the new century brought for the young. If they crossed the law in a serious breach, they usually were treated like adults. Father Flanagan fought vainly to keep the six-year-old mentioned in this story from prison.

These young Omahans, caught idly smoking near a razed building, displayed a brassy world wisdom picked up on the streets and highways, not in schools, churches, or homes. Railroads made Omaha a crossroads for the wanderers of all ages and sizes. Mechanization and poor local growing conditions put farmhands on the road.

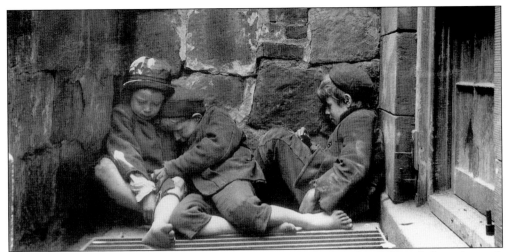

Homeless boys sleep in a New York City air shaft. Father Flanagan learned much from the work of Riis and from his own observations. Years later, when he visited Tokyo after World War II to advise on the homeless, guided by this experience, he wandered nightly in underground railroad stations where the homeless slept. *Jacob Riis Collection, Museum of the City of New York.*

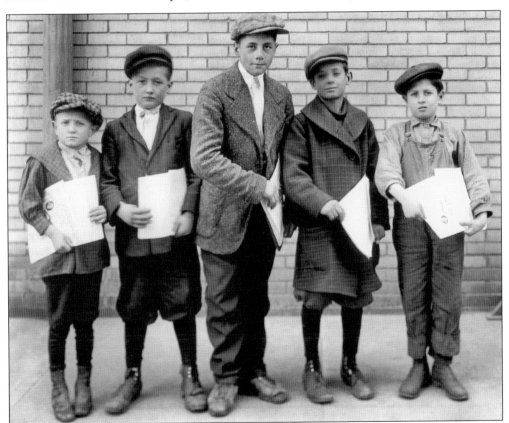

In March 1918, this ragged five appeared in downtown Omaha, hawking the new *Boys' Home Journal*. It was the home's first money maker. The *Journal* published monthly until 1936, when it became the *Boys Town Times*.

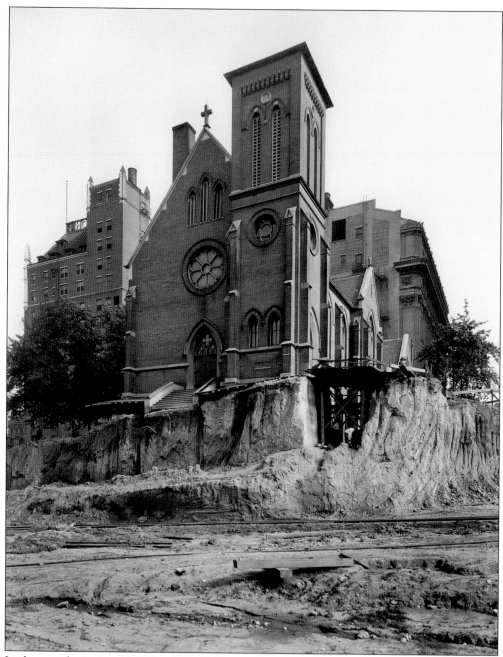

In the award winning film "Boys Town" 20 years later, Mickey Rooney is shot and takes shelter in an inner-city Omaha church. The church, St. Mary Magdalene, at 20th and Dodge Streets, was on Dodge Street only a few blocks from the first Boys Town at 25th Street. It is shown in this dramatic Bostwick photo as it looked in 1917. A steep Dodge Street hill was being shaved down and accommodations had to be made bolster the church up for a new entrance. *Durham Western Heritage Museum*

With 100 boys by the spring of 1918, Father Flanagan realized that already he needed more space. He was surprised when in April, he had a benefit dinner and 4,000 showed up, raising $5,300. With that, he took over what is called the old German-American home, near Rosenblatt Stadium, home of the annual College World Series. The father and the boys moved in October. Sadness accompanied the move: the first death of a young resident, to influenza during the worldwide epidemic.

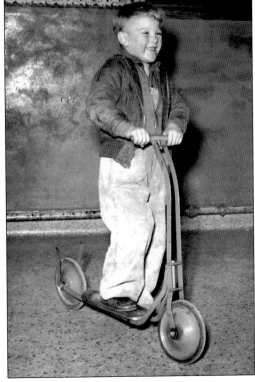

A boy on a scooter can go a long way and be pretty happy about it as this early times photo shows. Early holidays were skimpy. The first Christmas dinner main course in 1917 was sauerkraut, donated by a merchant. In later years, Boys Towners became very adept at making sleds and the sliders were popular at Christmas.

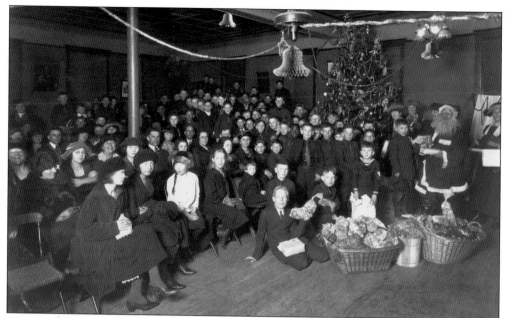

The first Christmas at the German-American home also featured Carlo, the boys' pet dog for many years. Disappointed he had been able to provide very little the first holiday, Father Flanagan read of a young dog for sale north of Omaha, rode out on the trolley, and bought it. The trolleyman wouldn't let him back on with the animal at his return, so the priest walked some five miles back to the heart of Omaha with Carlo.

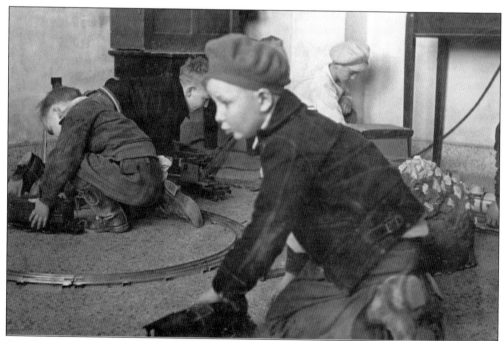

An electric train could keep several busy. Today, the girls and boys of Boys Town participate in more traditional holidays at the hearth of their group homes under the family home system. The standard in the earliest days was to get community gifts the entire home could enjoy.

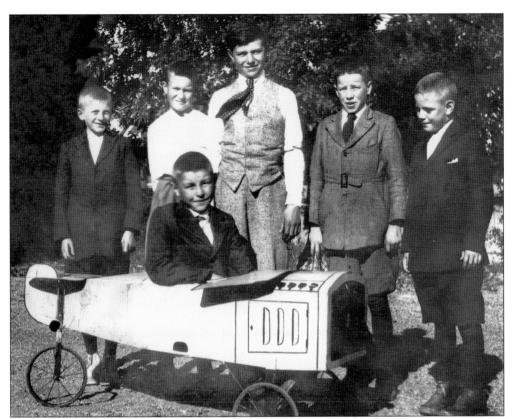

An airplane car was a big attraction as a Christmas gift at the German-American home. By now, the home was raising some of its own food and had chickens. Father Flanagan asked backers for a "pig or two" in every edition of the *Journal*.

Because of their wanderings, the boys found themselves teased because they lagged behind other public school students. In 1920, the home established its own classrooms with both nuns and lay teachers.

Bostwick, shown here with one of the five Packard touring cars he owned, seemed to be what the picture presents: a successful photographer at home with the rich and famous of the day. From 1907 to 1943, his photos appeared in the most prominent homes of the area. But his work which would become the most reproduced, most famous of all, was snapped for free. *Durham Western Heritage Museum.*

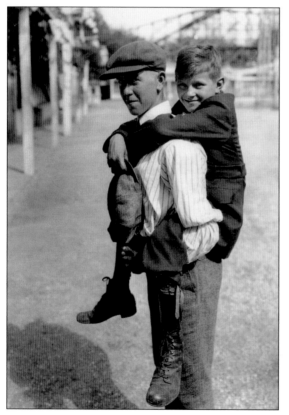

"He ain't heavy, Father, he's my brother." Those words, uttered to Father Flanagan in the dawn days when he encountered a small lad piggy-backing on another, caught the priest's heartstrings. He told Bostwick about it later. It also snagged the photographer's emotions. At an outing, Bostwick restaged the episode and shot it. The picture and replications of it became the Boys Town trademark in the 20th century.

Omahans soon began taking the new residents into the community. They were the guests of the theater when they attended this film on Thanksgiving Day in 1920. In return, Father Flanagan formed first a choir, then a band, and they performed wherever they were wanted.

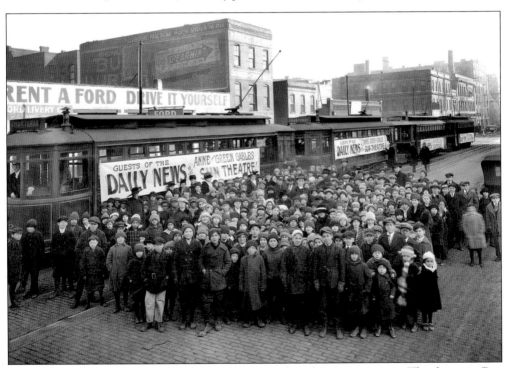

Not to be outdone, the Omaha *Daily News* made the boys home its guest on Thanksgiving Day the next year. The boys were transported downtown by the old-time trolley cars. By the end of 1921, of the 1,300 boys who were in or had been through the home, only 386 were Catholic. More than 900 were non-Catholic and 55 were Jewish.

Mr. Frank Beymer, Editor, December 1, 1923.
The Avoca Journal,
Avoca, Iowa.

My Dear Friend Frank:—

Many times I have told you that your paper contained all the local and interesting news.

In looking over your latest issue nothing pleased me more than to see that Father Flanagan's band and his collection of artists are going to be with you and give a performance in your city.

They have always participated, and helped me in celebrating my Christmas dinner where I feed many hundreds. Their playing is so wonderful, and so much appreciated by all; and the cause they represent so worthy that it is almost impossible to put it in words.

I only hope that the weather will be good and you will have one more visitor in your live city that I know of on that day. However, old pal, you can't say anything too great or too good about those wonderful boys.

Yours and yours truly,

(Signed) ERNIE HOLMES.

Ernie Holmes didn't run a pool hall, but a billiard parlor, in downtown Omaha. Every Christmas in a big charity event, he fed hundreds of the city's homeless, making Ernie Holmes a sort of pool hustler with a heart of gold. One Christmas, the choir from the Boys' Home sang for the group, and also shared Christmas dinner. As this letter attests, Holmes was delighted and ever after was a fan of Boys Town and Father Flanagan.

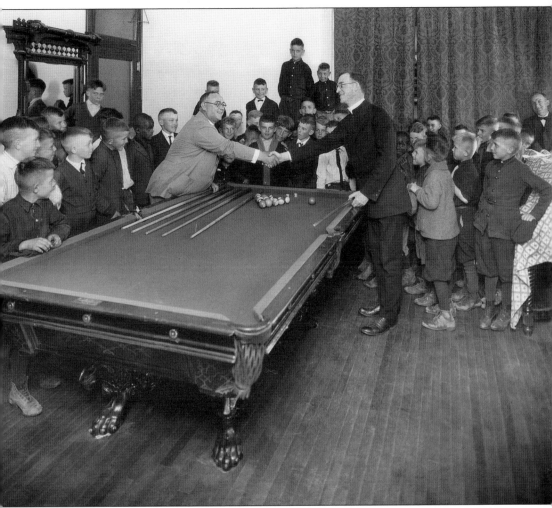

On Christmas 1923, Ernie Holmes fed a record 2,500, with the choir entertaining. It was the largest holiday charity event of its kind that year. Holmes is shown here with Father Flanagan and the chorus, shaking hands over one of the 35 tables.

Holmes became so fond of the home and its inhabitants that when he retired, he refurbished a pool table and gave it to Boys Town. It served its purpose at the modern Boys Town until those unconventional Christmases at Ernie Holmes' Parlor were just a faded, misty memory.

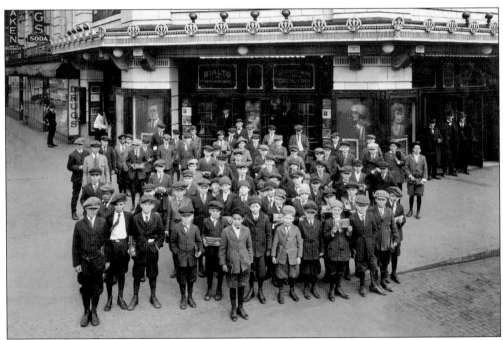

A home expedition to the Rialto Theater in the 1920s. Both because of performances they presented and the novelty with which the public conceived them, the boys were much in demand in the early days, so much so that Father Flanagan began to curtail their comings and goings to keep both school work and Boys' Home work on schedule.

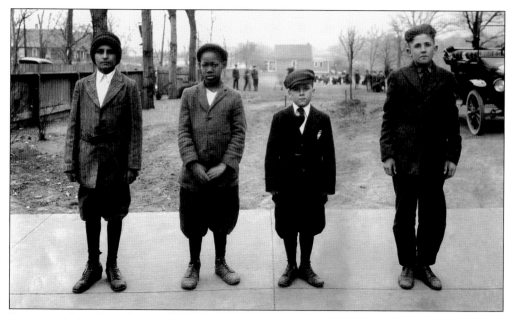

From its earliest days, the standards were interracial, inter-faith. Father Flanagan felt there was danger for all in "an ideology which discriminates against anyone politically or economically." Although the ideal induced sensitive moments, it was maintained. This photo was snapped less than one year after white Omahans broke into the county jail, took out a black prisoner who had been convicted of nothing, and lynched and burned him.

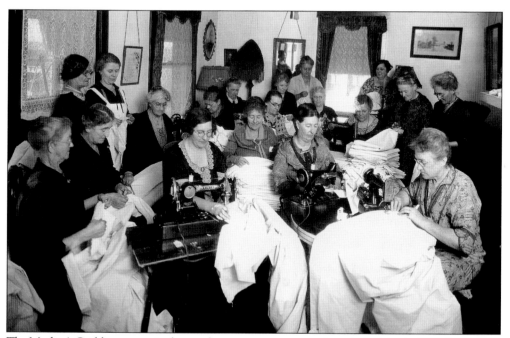

The Mother's Guild was organized as a volunteer group to sew and repair clothing in 1920. Its meeting on Thursday, shown here to be a busy affair, was called Mother's day. Their efforts were appreciated by Father Flanagan, and he lauded them in Edwardian prose over the years for the sunshine they spread in the lives of "poor boys who have been deprived of their own dear mothers."

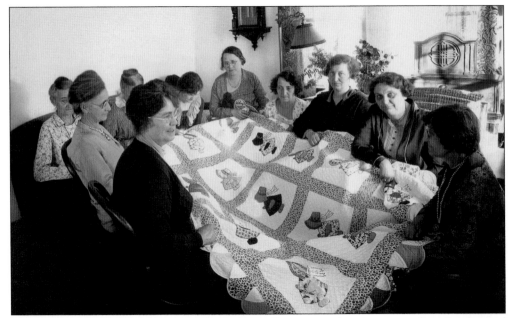

The Mothers' Guilds became very active in the smaller cities and towns surrounding Omaha, and they brought with them some vanishing American home art forms. The Nebraska City Guild is shown here finishing a quilt in the winter of 1921. Quilting still is a popular craft in Nebraska.

At one time, Boys Town Mothers' Guilds existed in ten other states across the United States. The group collected monthly dues to buy extras such as camping equipment and Christmas decorations with the proceeds. The 1920 Christmas tree was donated and decorated by the guild. They are shown here with Father Flanagan as guests of the Valley Commercial Club at a picnic in Valley.

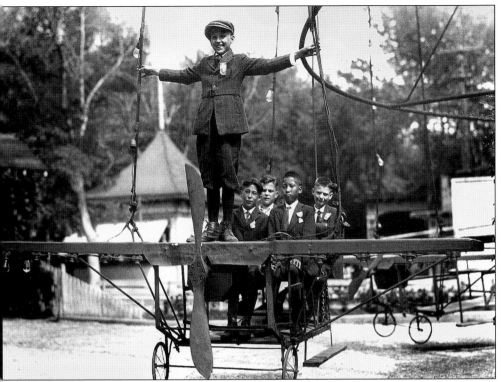

All in all, excitement stretched before the boys and Boys Town in the 1920. This Bostwick photo shows Boys Towners on an early trip to Krug Park. The boy seated on the left became a musician, was married at Boys Town, and a grandson today works for Boys Town.

And the excitement came to the boys. Soprano Lillian Breton appeared at the home and entertained in 1921, to the high hilarity of the boys. The Drury Lane, London, actress and singer was accompanying Irish tenor Thomas Egan, who sang a benefit in Omaha for Boys Town.

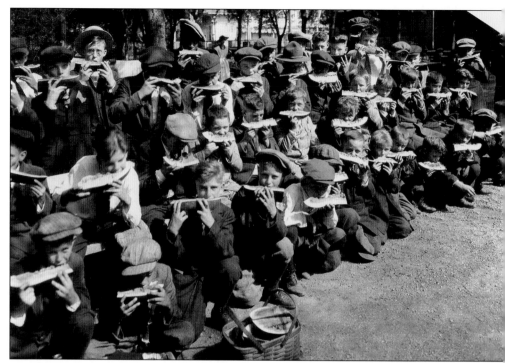

Watermelon at Krug Park, in late summer of 1921. This outing came only a few weeks before the home moved to its permanent location west of Omaha. Its residents continued their trips to the park until tragedy and sadness erased the park from its long-time place on the scene. In the early 1930s, a roller coaster crashed, killing several. Krug never outlived the bad publicity it received and the park disappeared.

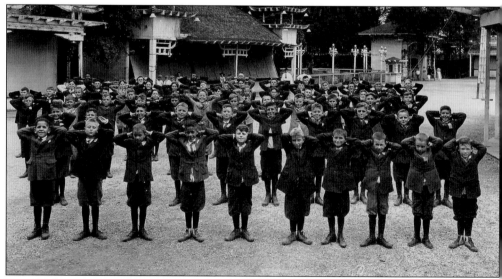

Krug Park was very popular with the boys of Boys Town in the 1920s. So much so that occasionally they got a little rambunctious. Here, Father Flanagan often had them do exercises to settle them down before entering the park. Photographer Bostwick, who took this picture, accompanied the boys on many of their excursions.

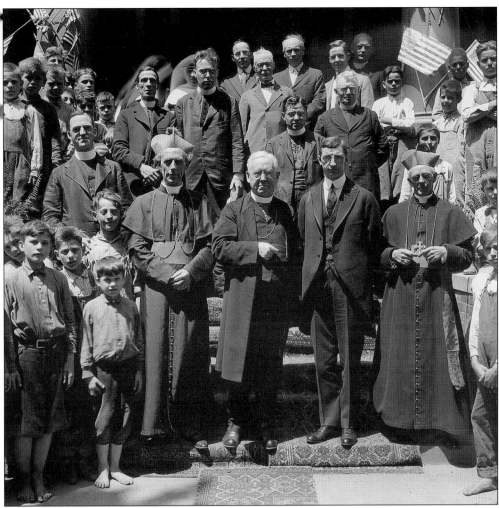

Eamon de Valera, Irish republic leader and later prime minister, had more than one reason to visit the new Boys Home when he came to Omaha on June 24, 1920. His wife and the mother of their six children was a Flannagan, (cq) Jane, but no known relation to the priest. Also an escapee from an English jail, he was raising $5 million for the Irish cause. Shown here from left in the front row, flanked by barefoot residents, are: Father Flanagan; Archbishop Daniel Mannix, Melbourne, Australia; Omaha Archbishop J.J. Harty; de Valera in the frocked coat; and Australian Bishop Joseph Higgins. It isn't known if the lack of footwear was a calculated appeal. But it was the third day of summer and "goin' barefoot" was pretty well accepted in the best of families anyway in those days.

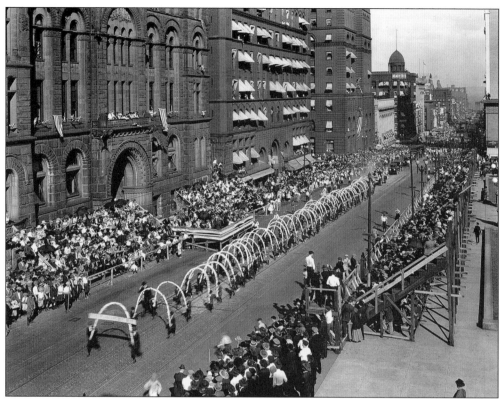

By September 1921, Boys Town groups were in demand about the city. Here they are shown marching with flower arches in a floral parade in front of Omaha City Hall, to the left.

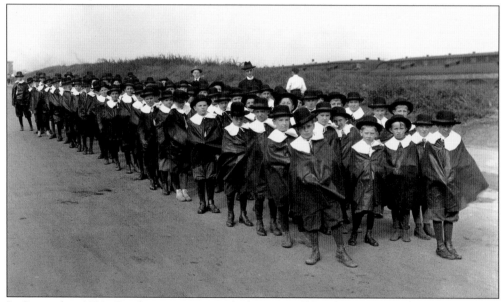

In September 1921, Omahans were amused when a small band of Protestant Pilgrims showed up for a fall parade in the command of a Catholic priest. By this time, the home was getting crowded again.

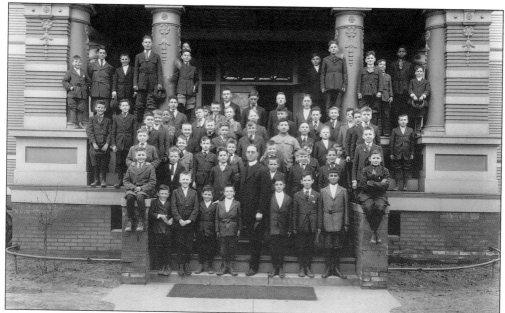

The boys looked well, as this photo in front of the home shows. In four years, it had provided for 1,107 non-Catholics, 626 Catholics, and 57 Jews. Father Flanagan had to look far from the city for a new home. He located a spot in the north side of the city but abandoned it. Clergy in the area objected that they didn't want "delinquents" in the neighborhood. The priest began to look far outside the city.

Of the residents, 24 were "tagged" boys like this one pictured by Louis Bostwick. They wandered in with few possessions and tags reading, "Father Flanagan Boys Home, Omaha, Neb." Most didn't know or remember their parents. Charities had sent 1,379 and the courts had sent 87.

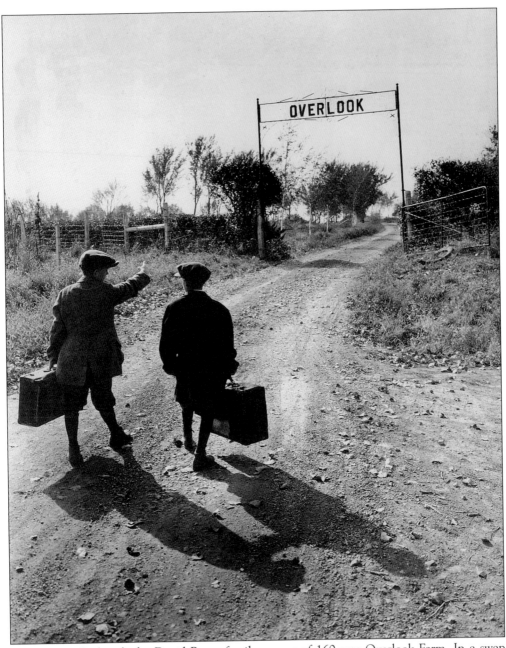

The priest talked with the David Baum family, owner of 160-acre Overlook Farm. In a swap arrangement involving a smaller farm the home already owned, Overlook was purchased and the boys moved into what was to become their permanent home on October 22, 1921. These two boys are shown walking up to the main gate near and 144th Streets on West Dodge Road. They would sleep in farm buildings and barns during a drive for $300,000 for permanent buildings.

Two

Is it Omaha or O'Maha?

A Long Way from County Roscommon

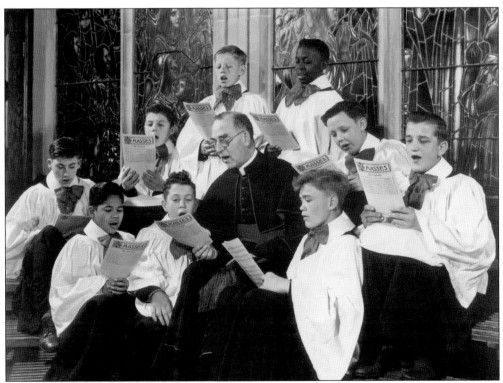

By the 1940s, the boys' choir that used to sing every Christmas in Ernie Holmes' old downtown pool hall certainly was different. It became an effective method of evoking first national, then world, attention to Boys Town. Travel over the entire globe for members, shown here with Father Flanagan at a Boys Town Christmas, became a way of life.

ABOARD THE SS CELTIC

Old frontier doggerel had it that Omaha was just another Irish town without an apostrophe, so much was the flow of the Hibernians after railroads opened the west.

Probably Edward Joseph Flanagan didn't even scan it on a map when he sailed from Ireland via the SS Celtic in 1904, bound for his destiny, albeit by an indirect route. The Flanagan clan, at varied stages, was joining other kinsmen in leaving the isle for the New World.

His father and mother, John and Nora, had occupied Leaberg House, in County Roscommon skirting the River Shannon, for several years as managers of the farm. It was a large family: four boys and seven girls.

Poor health dogged Edward J., born on July 13, 1886. He almost died in his early years and colds and respiratory attacks hampered his school years. There was a driving factor for the youth. Both Edward and his family wished him for the priesthood. That is what put him aboard the Celtic with brother P.A. in 1904.

Fates seemed to conspire against the tall, angular seminarian. He earned the undergraduate degree and entered St. Joseph's Seminary in Dunwoodie, N.Y., but double pneumonia felled him. His parents had emigrated to America, so Edward joined them in a move to Omaha, where an older brother already was a priest.

St. Joseph's had noted him as "a nice gentleman but delicate in health...just fair in talents."

The Omaha Archdiocese saw more talent and gave Edward the chance to study in Rome. There a bone-piercing winter brought on more respiratory problems and by 1908, he was back in Omaha to recuperate. Well again, by 1909 he was sent to study in Innsbruck, Austria, and the Flanagan fortunes took an upswing. In 1912, Father Flanagan was ordained, marking the end of an eight-year quest.

After brief service in O'Neill, NE, Father Flanagan returned to Omaha in 1915 for assignment. With a stagnant farm economy, the city seemed awash with unemployed young men and boys.

The priest had seen it before, in Ireland, in the cities as a seminarian, even in the countrysides. There was no work, no shelter, and little food. Churches helped, but usually only with a meal or two. Father Flanagan contacted the St. Vincent de Paul Society, pulled together help from other sources, and fashioned an old hotel into the Workingmen's Hotel. Here, he began to understand his method which he termed, "so basically wrong." These men were orphaned or abandoned or came from large, economically-stretched families or divorced families.

Describing them as "shells of men," he later wrote, "I knew that my work was not with these shells of men but with the embryo men—the homeless waifs."

Then he did something new and revolutionary. The Rev. Clifford Stevens, a priest and Boys Town graduate, described it as a "totally new orientation."

"He reversed the public image of the homeless boy and made it respectable. Then he battled to change the public image of the 'bad boy,' the delinquent. He created the Boys Town concept of the boy, not as the ward of an institution or the inmate of a home but as a citizen in a state of formation but already possessing dignity and rights," Father Stevens wrote.

Father Flanagan established his home ignoring race and religion lines and replacing the moral, ethical, and educational venues of the good home and society, franchises unattainable for the wandering, wayward youth.

It crossed the grain of existing child care provided by societies or religions or rich people's money and the industrial homes of the public body. When in 1983 the United States Department of the Interior marked several current Boys Town buildings in its Register of Historic Places, it observed:

"Boys Town is significant because it led the development of new juvenile care methods in the 20th Century America. Boys Town has been unique since its inception and continues to be the recognized prototype in public child care."

He plunged into bold financial ventures with a recklessness that may have endeared him to many Americans of that time. "God will provide," he would say. When he landed Overlook Farm, which was to become Boys Town, the former owners announced that the best thing Father Flanagan had going for him was faith. He got his story out in a cornball manner that might have made modern public relations blanch—and that may have endeared him, too.

His ideals put him in frontal battle with established standards in 1940, after some suicides at a public boys' home called Whittier School in California. There were beatings and punishing incarceration tantamount to solitary confinement at the place and Father Flanagan, appointed to a commission to investigate and recommend, lashed out at corporal punishment.

At the end of World War II, his stature projected him to a commission to consider methods of alleviating youth homelessness brought on in Japan and Korea by the war. His success sent him on a similar trip to Europe in 1948—and to his death of a heart attack in Germany in May at the age of 61.

Thousands of mourners lined the passage of his return to Omaha, the city of his destiny so many years before.

"He was the only father I ever knew," said one Boys Towner.

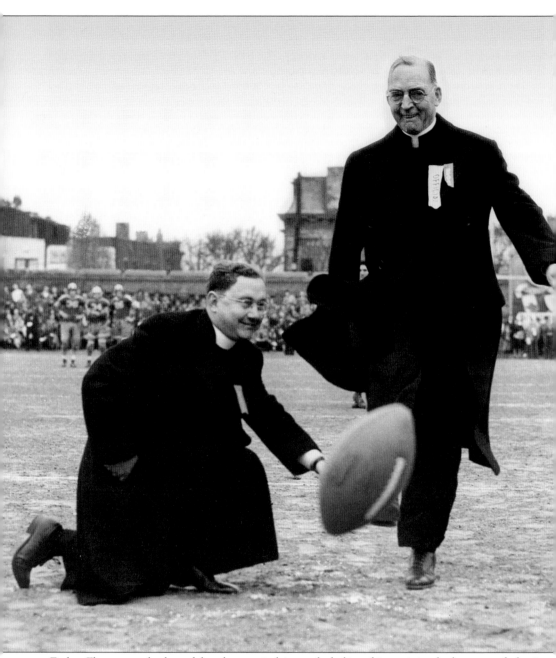

Father Flanagan, who boxed for pleasure in his youth, believed in activity for boys—and also in getting the message out about Boys Town. As a result, his football teams traveled and he went with them, developing a good kicking game as this place kick prior to the Boys Town-St. Michael football game in Union City, N.J., in 1943 shows. As the fame of the home grew in the 1930s and 1940s, the priest became as big a draw for fans as the games themselves. After the award-winning movie, "Boys Town," came out, the attendance of Boys Town football games often exceeded those of major colleges that were playing the same day.

He would try anything to spread the Boys Town message, even the new-fangled machine called a radio. Father Flanagan appeared more at ease kicking a football, however, than talking into the mike.

Three daughters were absent when this Flanagan family photo was taken in Omaha in 1908. In the front row, from left, are: young Edward, John, Mike, Nora, and Father P.A. In the rear, from left: Dea, Theresa, James, Nellie, and Susan. Young Edward Flanagan's health was flagging as a result of a wet, cold winter in Rome and old childhood lung problems assailed him. At this time he was working in the Omaha packinghouses. Within a few months, still seeking the priesthood, he would re-enter the seminary world, this time in the venerable old university at Innsbruck, Austria.

All of the Flanagan family passed through famous Ellis Island on their way to America's Midwest. This photo was taken at Ellis Island. It shows brother P.A. at the right side and Edward J. next to him, landing with other immigrants in new world.

The Flanagan health rebounded quickly in the dry Austrian mountain air. He is the student at the rear in this picture, clowning as they ascend one of the mountains near Innsbruck. He later recalled the Austrian days as among his happiest.

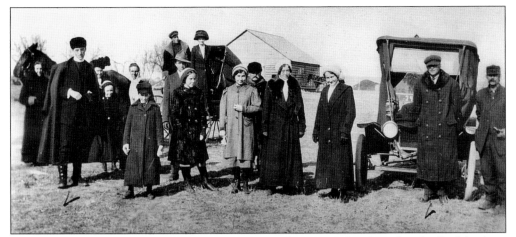

This 1912 photo shows Father Flanagan with parishioners at his first church, St. Mary's in O'Neill, NE. This part of America was wedged between 19th and 20th centuries: Model-Ts still met horse-drawn on dirt roads. The priest, already aware of homeless urban America, no doubt got his first view of rural problems and the countless men tramping the lanes and countrysides looking for farm work.

The idea that grew into a national, many-sided program affecting the lives of more than a million American young people started in this building, at 11th and Mason Streets in the seamy underside of Omaha. Torn by what he had seen in America's cities and its countryside, Flanagan founded his Workingmen's Hotel. He soon saw that he was on the wrong end of the homeless spectrum trailing the Industrial Revolution. The wanderers he met had been wandering since youth. It was too late, he felt, to help them. Omaha Archbishop Harty, a supporter, relieved Flanagan of all parish duties in 1917 and the work for Boys' Home began.

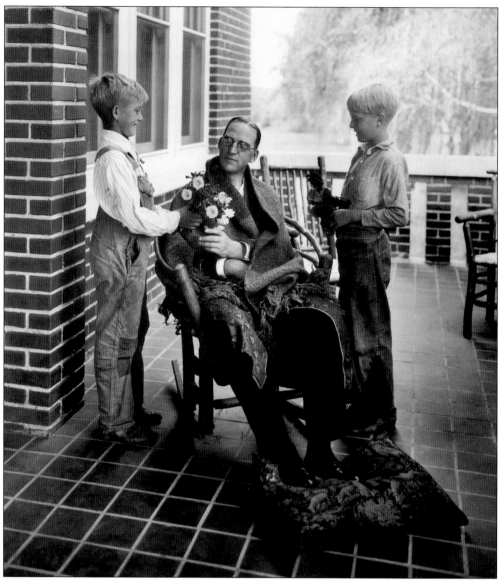

The Boys Town mood became one of fear and uncertainty when Father Flanagan was flattened by old lung problems in 1931. He was transported to a hospital in Denver and the boys back in Omaha received daily accounts of his health. This photo shows a thin Flanagan receiving flowers from two of the younger boys upon his return to the home.

The priest was swamped by children everywhere he went. He also met many ex-BoysTowners throughout the Far East. At the conclusion of the trip, he presented a long list of recommendations to the Japanese provisional government. Many were enacted in June 1948.

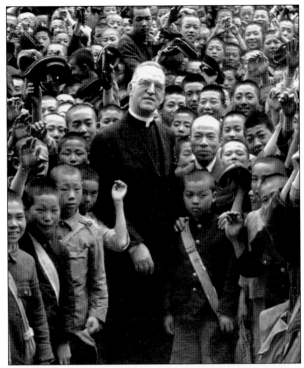

Directly as a result of the Far East tour, Father Flanagan met with President Harry Truman a year later and toured Western Europe in the spring of 1948. It was on this trip that he died of a heart attack on May 15.

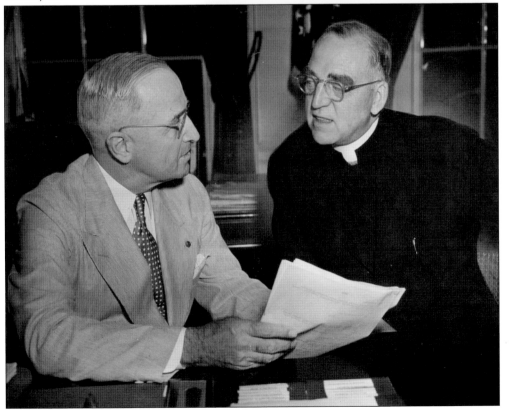

Father Flanagan died on May 15, 1948, the day that Israel became a Jewish state, less than a year after his friend, Henry Monsky, so vital to the building of Boys Town, also died. It was observed that this friendship of Christian and Jew exemplified the spirit of brotherhood. Between the two men, they had seen the meager enterprise in faith that began in a single home in Omaha blossom into a new approach in youth care. Father Flanagan's body was returned to Boys Town for service and burial. Thousands lined the 12 miles from airport to the center. It was estimated that in the two days the body lay in state, 30,000 filed by to view it.

Three

SETTLING IN

From Shaky Footings, A Strong Foundation

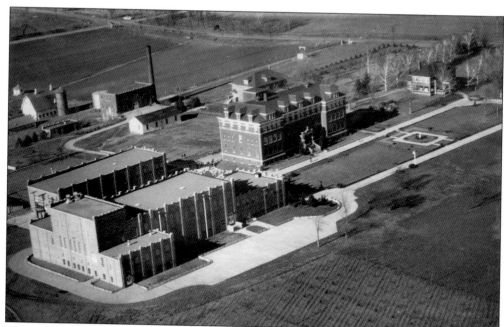

This is what the home looked like by 1930. It would ultimately grow from its 160 acres to 1,300, most of it in farmland. The two big buildings here are the administration and school, at left, and Old Main, in the center. Cultivated fields stretch behind both. In the fall of 1921, a lot still had to be done.

"Oh, This is the Most Beautiful Spot"

When Jim Edwards, at the age of 86, made his only return to Boys Town in 1991, even after a 70-year hiatus, he had good reason to remember the first time he saw it. He had to sleep in a chicken coop.

"Oh, this is the most beautiful spot,"exclaimed the larger of the brothers in the statues and pictures of the Two Brothers. Jim had been carrying a smaller home member, a handicapped boy, when Father Flanagan addressed him. The boy's response was somewhat historic: "He ain't heavy, Father, he's my brother."

The lines, with images of the two boys, later became the logo for many years of Boys Town. It was also the title of a popular song 40 years later.

Edwards, 16 by the time the move was made to Overlook Farm in October 1921, was one of the larger boys. He had to go out to Overlook early to prepare for his younger companions. Boys slept and went to class in farm outbuildings, meals were cooked at the farm house. and the youths ate wherever they could. Edwards himself left at the end of the school term, as was the custom, worked his way about the United States, and wouldn't return to Boys Town for 70 years.

The temporary quarters would remain in use until the first building, Old Main, was completed in 1923. Father Flanagan had begun a drive for $300,000 to finance it and other buildings. The priest and the boys also started other fund raisers. They had been quite successful as the Sanitary Products Co., making soap and disinfectants in the basement of the old German-American Home. In 1919, they had made $14,000 and in 1920, they made $18,000. But business dropped off.

The boys started making and selling brooms and sleds. They also formed variety shows and toured the area with only the slightest degree of financial fortune. In 1926, its variety show traveled 4,500 miles, getting as far west as Puget Sound in Washington. An instructor from the New York City School of Dances volunteered her services and the troupe became experts at the Charleston.

By 1927, about $107,000 was owed by the home. A special drive was conducted to pay off the mortgage and avoid refinancing but it fell $30,000 short. Boys Town refinanced and once again was back in debt.

In 1931, as hard depression began, the home was penniless. Contributions had begun to drop off. New boys were being turned down. Friends and the bankers had to keep the center open.

Father Flanagan was determined that the farming at Overlook would pay off. The purchase

had included the farm's livestock. Flanagan added to the dairy herd and by May 1922, the farm was churning and selling 200 pounds of butter and 200 pounds of cottage cheese a month.

This was the beginning of an agricultural significance at the farm. Before it began to winnow, Overlook, now formally Boys Town, would spread over 1,300 acres, with most of it consumed by farming and the agricultural vocation programs.

Like its finances, the home's ag programs suffered a setback in the 1930s with the Depression and the accompanying drought. Nebraska was in the heart of the Dust Bowl. Several crops were lost. Many times the boys had to form bucket brigades to irrigate the truck garden that was feeding the home.

But the home survived and the farm flourished. During its greatest years, in the 1950s, Boys Town had a dairy herd of more than 200 milk cows. A test herd of Boys Town cows were cited nationally for turning out more than 6 tons of milk during the test period.

Its beef cattle won so many prizes in shows from San Francisco to Chicago that Boys Town for years held its own championship show. It also fed as many as 400 hogs and 500 sheep.

As the City of Omaha grew out to surround Boys Town, it had to curtail its farm program. By the middle of 1970s, the vocational agriculture program was dropped.

Always alert to new methodology for reaching out to more of the public, Father Flanagan took to air waves quickly as radio advanced. The Boys Period began airing for an hour weekly in 1926. The regular fare was advice to boys. Girls also wrote in to the program and Father Flanagan responded to their inquiries by mail. The programs of Johnny the Gloomkiller, with upbeat messages of the day, were very popular.

Then, in 1928, two boys, seven and nine, were sentenced to a men's reformatory in Missouri for burglary. Father Flanagan wrote to the Missouri Governor about the inappropriateness of the sentence but the governor replied that they, after all, were criminals. The priest took the sentence to the radio.

Under public criticism, the two boys finally were turned over to the Missouri Department of Charities.

The home continued to limp along, financially. Respect for it continued to grow. Father Flanagan spoke out in many cases where he thought harsh punishment for the young appeared. His was a voice heard, whether by judges, governors, or cartoonists.

Before the end of 1921, crews already had stripped off part of the old farm structures and had dug foundations for the new center. The task looked overwhelming: housing, chapel, dining room, offices, classrooms. Until the main buildings were erected, temporary farm buildings and chicken coops were renovated as living quarters.

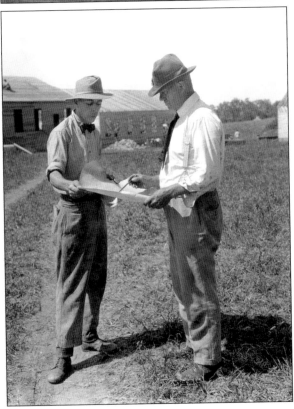

Two foremen consider plans for the new home. Although in 1921, the center was on a gravel road, Dodge, a long way from Omaha, that was to change in a few short years. Dodge had been designated as part of the great transcontinental Lincoln Highway and ultimately, millions of people would drive past the location.

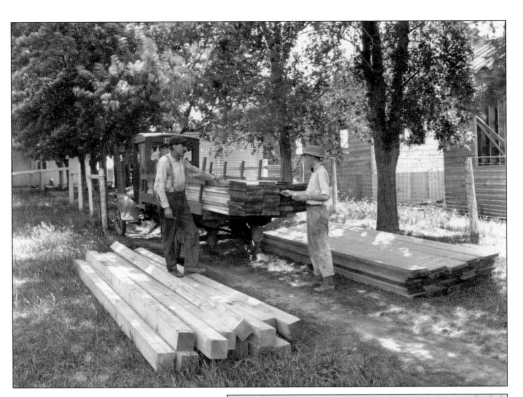

A crew unloads supplies for construction at the farm, which was very important to the founder whose intent was that it should provide most of the food for the home. Under the advance of modern food preparation and the expansion of the city, within 50 years, farming would take a back seat to other activities.

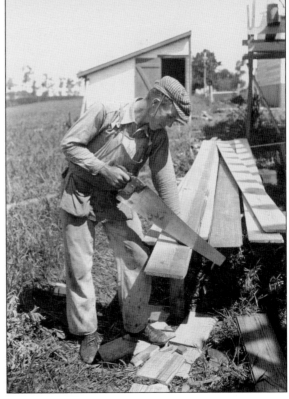

This worker is sawing lumber at the edge of a field already plowed. The home needed $300,000 to put up the first building and for the next 50 years was to be out of debt only a few times. J.E. Davidson of the Nebraska Power Co. organized a funding campaign even before work began.

The boys took part in finishing up the Old Main Building. The public was curious and bypassers frequently stopped to watch. Less than 10 days after work began, Father Flanagan started inviting Omaha groups out to behold the project. Each day a different group came for lunch and was guided about and entertained by the young residents.

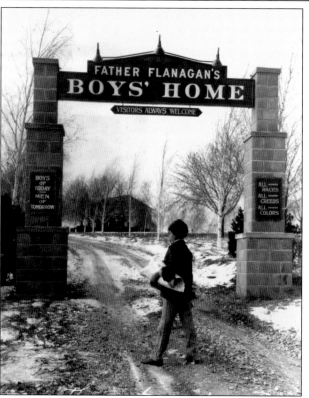

Father Flanagan felt it was vital to reinforce the home's tenets about race, creed, and color. One of the first things erected was a new gate outlining the openness that was to become a Boys Town tradition. The gate was donated.

The boys lived in temporary farm buildings during the home's first major projects. Food lines could get pretty long as this picture by photographer Ernest Bihler shows. The Flanagan idea was that if the home had enough land, it could raise enough food to pare down costs so that payments on mortgages and interest could be made.

In the first days, boys ate where they could. A favorite place, above, was the back door of the farmhouse. Four bushels of vegetables were consumed a day and 120 gallons of milk a week were downed.

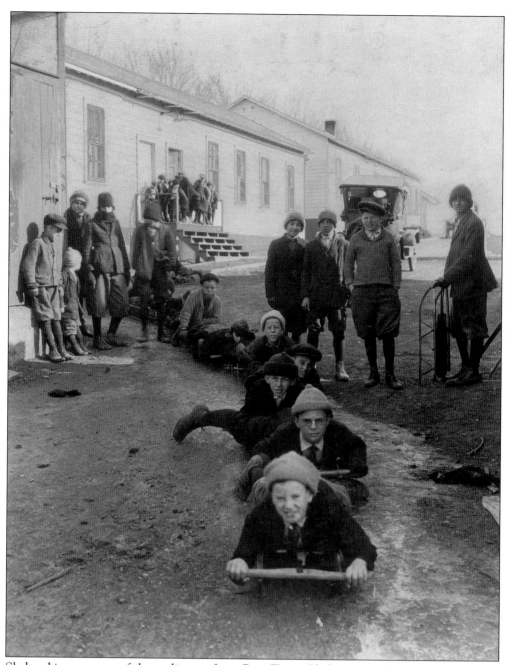

Sled-making was one of the earliest crafts at Boys Town. Sleds were under many Omaha area trees the Christmas of 1921. Finding a place to use them was another matter. The residents here found a patch of ice at the rear of one of the farm buildings. This building also was serving as one of the dormitories.

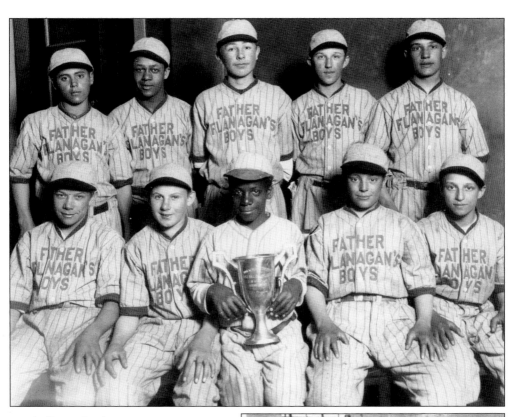

Baseball was the first competitive sport at the home and a make-up team won several games in 1921, while still at the German-American Home. By 1922, (above) the team had uniforms and was playing teams from surrounding towns.

The building of a recreation hall at the home proved to be a big boost for activities. The building shown at right served as a hangout on cold or rainy days for many years. It was even used for basketball and boxing until a gym was erected many years later.

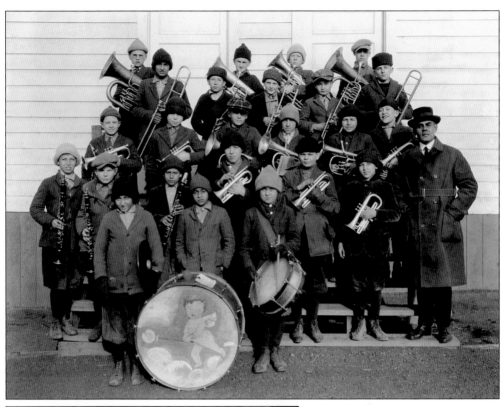

This photo was snapped at the first Christmas at Overlook Farm and it is the first Boys Town concert band. Dan DesDunes, right, one of the earliest Midwest American band leaders, helped form the band and pull it up to performance level.

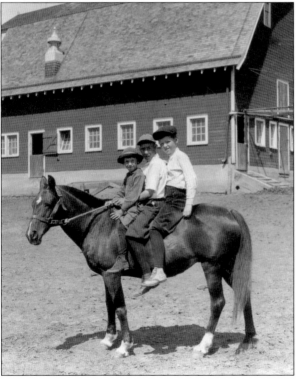

Everything in those days wasn't just hard work and unpleasantness. This trio found time for a ride around the barnyard in 1922.

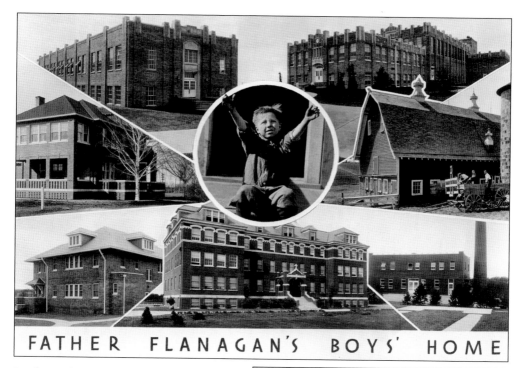

FATHER FLANAGAN'S BOYS' HOME

By the mid 1920s the home was well-settled at Overlook Farm, This collage showing several of the buildings centers about the picture of the Homeless Boy, also the original Johnny Gloomkiller, Johnny Rushing. Actually there were several Gloomkillers, appearing after the first Boys Town radio programs in 1926. They dispatched messages of good cheer, optimism, and faith which found their way into many Midwest homes.

On Mother's Day, 1927, the first Gloomkiller, who didn't remember his mother, made an impassioned plea about her: "I haven't even a picture of mother. If I had…I would hug it today," he said in a sad prologue to his regular positive address.

Within a few days, a grandmother had sent Johnny this picture of his mother, taken in 1914. Copies were made by photographer Bostwick so the boy, who arrived at the home in 1921 and remained eight years, would always have one.

The incident was never forgotten. Like their colleagues, many Gloomkillers found themselves in the service of their nation during World War II. That first Gloomkiller, John Rushing, is shown returning to greet Father Flanagan at Boys Town after the war. He had served 32 months in the South Pacific. He had left the home after eight years there to make his way in the world in 1929.

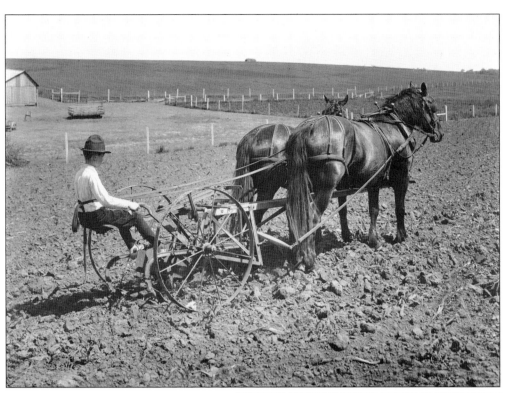

In spring 1922, Father Flanagan was itching to get crops in the ground and that meant hours behind a horse and plow, above. At this time, plowing was not new to most of the residents. At least half of the boys came from farms.

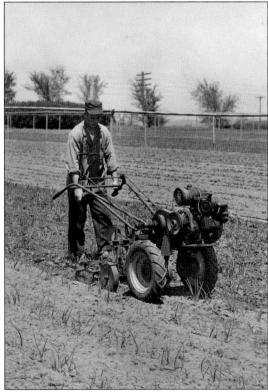

Contrast the old plow with the hand tiller used during the height of Boys Town farming days. This picture was shot during the early 1960s.

The home soon learned that performances by choirs and bands not only produced donations but also developed contacts in the form of admirers who would remain fans and supporters for years to come. On a Denver, CO, trip in 1921 the boys, some of whom had appeared before judges, were introduced to Judge Ben Lindsey for a social, not professional, visit.

Educations were broadened by meeting people in the news on trips to Colorado, Wyoming, and South Dakota. Here Boys Town marchers and manager A.H. Toher, adult on the left, meet Colorado Gov. Albert P. Shoup, and Secretary of State Carl Milliken in 1922. The boy on the far right is Charles Kenworthy, who built a regional reputation as a public speaker and announcer while at Boys Town.

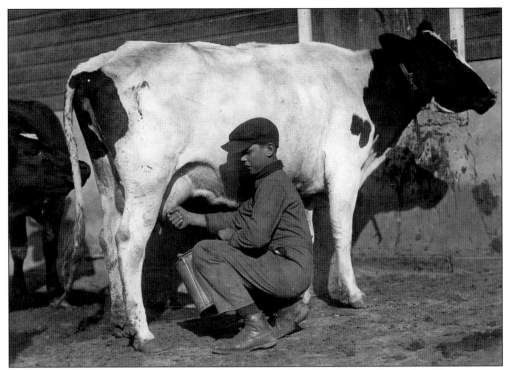

The picture above reflects a modest start to what became one of the most modern dairy systems in the Midwest. Boys Town dairy cattle set national marks many times over the years. The herd once numbered more than 200.

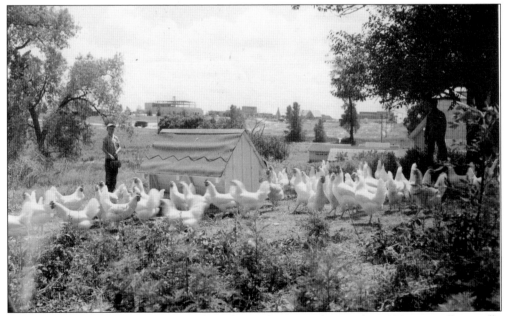

The home had chickens from its earliest days. The young farmers by 1923 were selling milk, cottage cheese, and eggs to produce markets in Omaha. The boys caring for the animals had to rise at 4:30 a.m. and finish their chores on the farm before breakfast and prayers.

It was a red letter day in late 1922, when Boys Town got its first cash crop, hay, to the market, shown above. By the middle of the 1920s, the home also was marketing corn and soybeans. To feed the hungry residents, the farm also had to produce three bushels of potatoes and slaughter one cow and six to seven hogs every week.

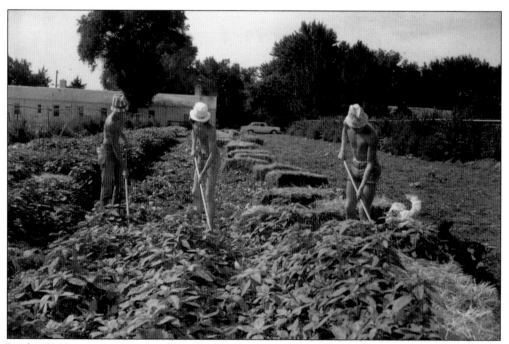

In the 1930s water was carried by the boys trying to save the truck garden, which provided much of its food. Even thought the importance of agriculture has winnowed, the garden still is maintained today. The picture above shows boys working it in the 1950s.

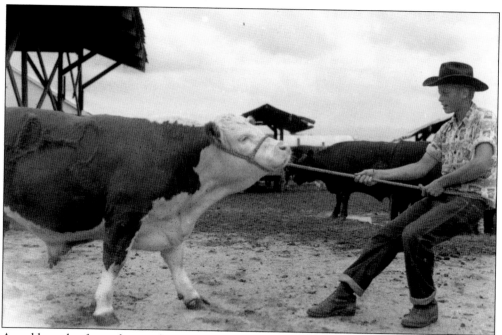

A stubborn beefer and a resident negotiate. At the maximum, the home had 400 hogs and 500 sheep in addition to several hundred cattle. A 4-H Club was one of the earliest clubs formed at Boys Town. The boys agreed to buy their animals and raised them under the tutelage and counsel of a herdsman.

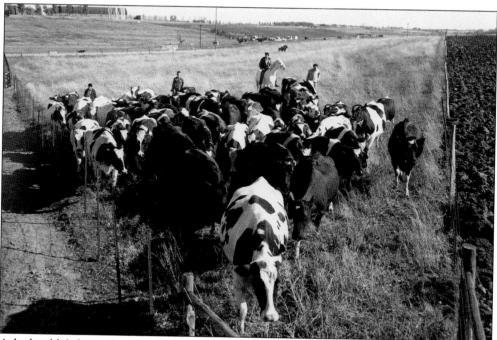

A little old-fashioned romance remained in farming, especially in herd-driving the cattle in from the pasture. In addition to top-producing dairy cattle, the home also developed talented cutting ponies.

During the Depression's Dust Bowl days, the home didn't escape the damage that most farmers suffered. This picture shows the terrific stress the lack of moisture of the drought placed on one crop. Boys Town lost three entire yearly crops and large parts of several others.

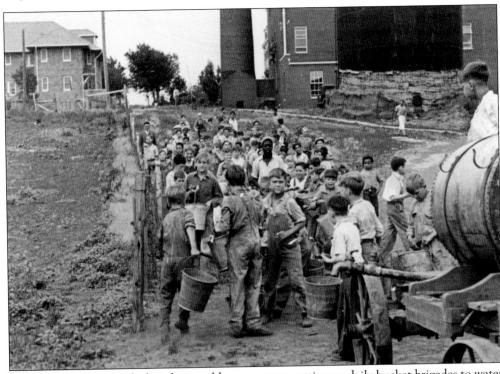

Boys shown above saved what they could one summer, setting up daily bucket brigades to water the truck garden. Sometimes it worked but sometimes it didn't. One graduate later recalled going to the cellar and finding only a handful of potatoes. "I don't know where Father got the food that day," he said.

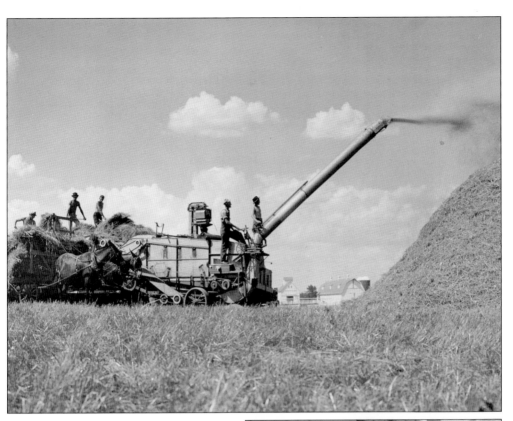

All worked. Members of the Boys Town Choir are working the thresher shown above, during the heyday of the farm operation. Regulations became so stringent in the latter part of the century that Boys Town quit processing its own foods and simply sold, farm to market.

"Lift a calf every day..." It isn't recorded if this 4-H member completed the old story. Boys Town beef cattle were top prize winners in livestock shows over the West and Midwest.

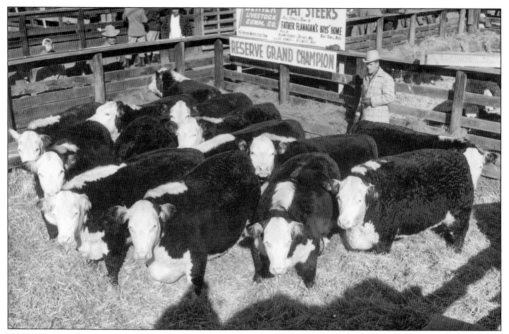

These Boys Town steers were prize winners at the Denver, CO, livestock show in 1950. The farm's stock was so successful in breeding and showing that the home for years held its own livestock show. The boys, who owned the animals, upon sale at such shows used the money to complete the purchase of the animal. They usually earned a good profit.

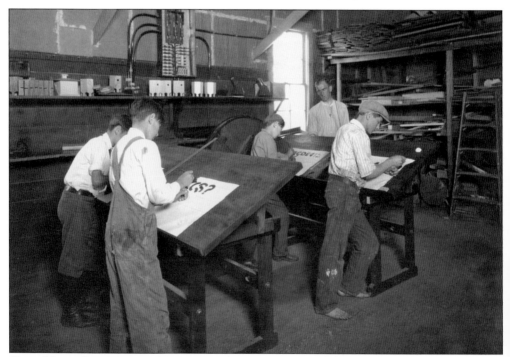

One of the earliest vocational courses taught was printing and the home was putting out its own paper in 1925. Note the barefoot boy at right.

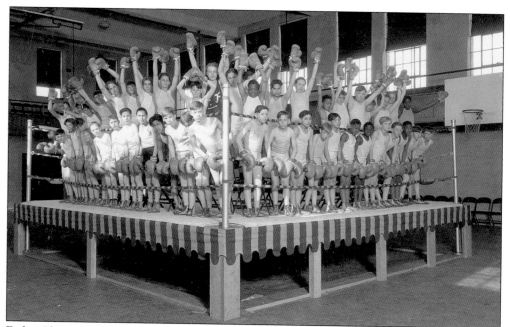

Father Flanagan, himself a boxer in his youth, felt knowledge of the sport was vital. So all boys ages 7 through 13 received boxing lessons, as shown above. The building is an early gymnasium which later burned and had to be replaced.

A double treat in 1929 was the visit of two ex-champions, Jack Dempsey, at left, and James Corbett, to Boys Town. Corbett was in Omaha for a stage show, Dempsey was refereeing a match. They were the vanguard of a long line of boxers visiting the home.

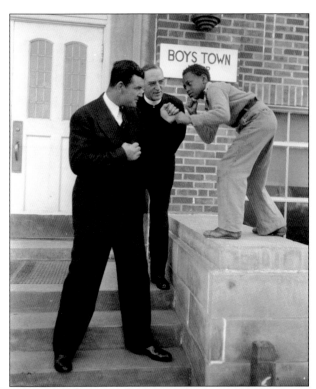

Few boxers could refuse a visit to Boys Town. Here James J. Braddock, another world champion, is shown with the priest and one of the residents.

The man who followed Braddock as champion, Joe Louis, was a great favorite at the home. Louis had just won the crown when this picture was taken. Newspaper accounts attributed to him some surprise over the quality of the home's boxing program.

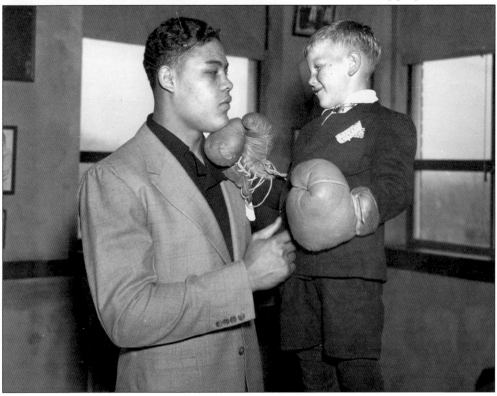

America's favorite cowboy star, Tom Mix, also visited the home in the 1920s. At this time, Mix was on the Orpheum Circuit and was the top money-maker. Talkies were on the way and Mix faded before the singing cowboys, who also visited Boys Town.

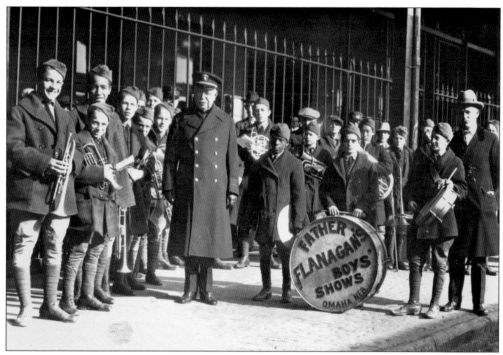

The Boys' Town Band was chosen to greet the march king, John Phillip Sousa, when he visited in January 1926. They played "Stars and Stripes Forever." Off to a ragged beginning in 1921, the band was playing to crowds numbering as many as 1,500 at this time.

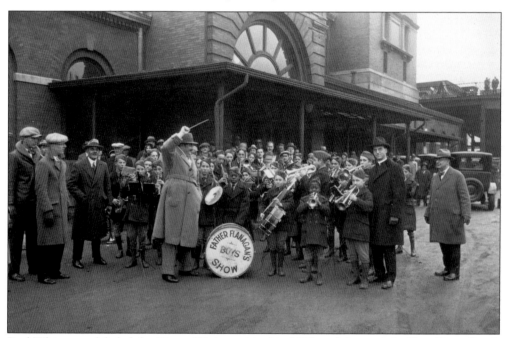

Paul Whiteman, labeled the King of Swing, visited in 1929 and directed the Boys Town Band. This picture was shot at Omaha's Union Station and the man standing directly to the left of the band was its leader, Dan DesDunes. He died not long after the picture was taken.

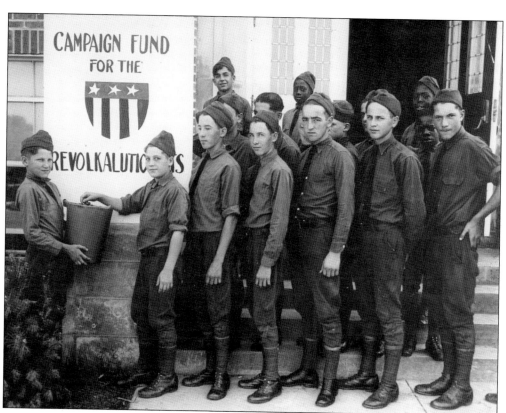

In 1930 the popular cartoon character "Skippy" had trouble: the Jacketeer Gang had invaded his hometown. The Boys Towners quickly organized the Revolkalutionist (cq) Party in support of Skippy. The move gained national attention including that of the cartoonist, Percy L. Crosby. The photo above shows the boys contributing to aid Skippy.

Cartoonist Crosby thereafter became a fast friend of Boys Town and frequently mentioned them in cartoons. It was only one of several self-generated Boys Town projects which attracted national spotlights. In another, the boys of Boys Town voted to donate all their milk every Thursday to the milk fund of a local newspaper.

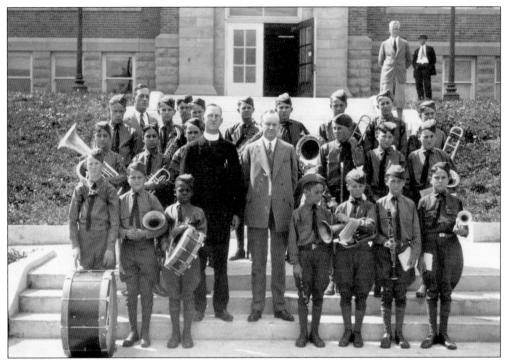

Silent Cal Coolidge was the first president to hear the Boys Town Band. He is shown here in Rapid City, SD, looking about as happy as he ever did, in August 1927. A few months later, he announced that he did not choose to run and bowed out of politics. He seemed not to be disgruntled with the band, however, as he asked it to play for him when he came west a year later.

Boys Town marble shooters are shown here beginning a tournament. Marble shooting was extremely popular for the first 40 years of the home and marble rings are still maintained on the grounds. A Boys Towner won second in the district tournament one year.

Four

THE ROAD
TO HOLLYWOOD

That's Entertainment

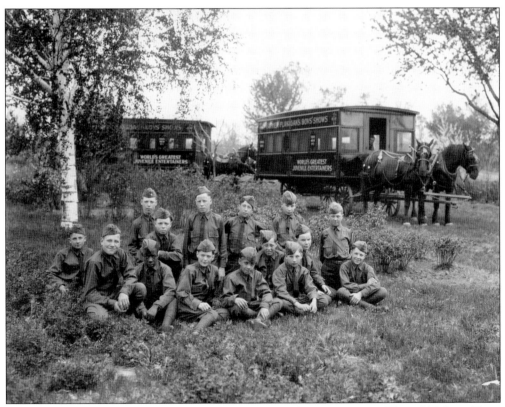

It was a modest acclamation: "World's Greatest Juvenile Entertainers." This 1922 Boys Town road show traveled by horse and carriage, slept under the stars, were stranded in south Nebraska, and limped home ten days late, penniless. But a few days later a Wisner, NE, farmer sent them the deed to a 40-acre farm.

There's No Business Like Show Business

The founder and first Boys Town director firmly believed young America needed a strong taste of self-determination, so elections were held on Feb. 14, 1926. Father Flanagan took it in good natured surprise when the biggest decision that day was to adopt the name of Boys Town.

It was a few years before the name stuck with the public but stick it did and these years were among the most colorful of the home. Its entertainers had made brief trips before but in 1922 the first major road trip set off for nearly three months through Nebraska. The mode of transportation was two large, gaily-painted wagons, drawn by horses. The boys slept under the stars almost every night. A reporter visiting one of the overnight stops said it resembled a boys' camp-out. In time, that halcyon aura wore thin, then vanished. In August, the youthful entourage was stranded for 10 days in southern Nebraska: no more bookings.

By the time the entertainers had returned home, the venture had turned into a money loser. Father Flanagan vowed no more horse-and-buggy. Thereafter the shows traveled by train, then finally by their own bus.

With its social groupings, the troupe sometimes had problems. In South Dakota, a café owner moved Oscar Flakes, the black star of the show, into the kitchen to eat. The priest and the troupe followed. No, no, the man said, you can eat in there.

"If we don't eat with him," said Father Flanagan, indicating Oscar Flakes, "we don't eat."

The group left. But that night the owner attended the show—and left a check for $500.

With no electronic entertainment beaming into homes, it was a time few Americans remember today. The major artists rode the major circuits in cities and larger towns. The bill of fare in smaller towns was second-line vaudeville, medicine shows, and variety shows like that of the Boys Towners. Then radio began to compete and even Boys Town had its own station for several years. Talkies made movies a bigger magnet. Traveling shows drew less and less. The last and most elaborate Boys Town show, a western extravaganza, set out in 1939 but made little money. The nights of 1,400 spectators at a show were over.

If Boys Town show-biz had trouble finding Americans, American show biz had no trouble finding Boys Town. The 1930s saw a flood of celebrities visiting Boys Town, culminating with MGM moving its crews to the village to make a film.

Boys Town had almost gone under in 1931, early in the Depression and supporters and the Omaha public came to the home's assistance. It didn't hurt when Franklin D. Roosevelt and his

wife, Eleanor, then campaigning for president, visited and thereafter spoke in admiration of it.

Boys Town got a post office in 1934, reinstated elections in 1935 and named Tony Villone as mayor. Then it was designated as an incorporated village.

The election idea fascinated America. Votes were held every year at the home. Pre-election rallies included stump speeches, big signs, organized parties like the HOT, Help Our Town, and the BBT, Build Boys Town. Those elected had specific duties. The press picked up on it. In 1936, Boys Town mayor Dan Kampan met with the Little Flower himself, popular New York City mayor Fiorello LaGuardia.

Then, in 1937, an important letter: the Metro-Goldwyn-Mayor Corporation would donate to Boys Town $5,000 to make a motion picture about the home. It would also pay $100 a week total to the director and others to act as technical advisors during the filming.

The great Spencer Tracy would portray the priest, Mickey Rooney would be a snarling, fictitious Whitey Marsh. Both were at the peaks of their careers. The film looked to be, and was, a cinch at the box office. Furthermore, Tracy won the Academy Award, which later was donated to Boys Town.

There was a flat note in this symphony of success. The public thought that Boys Town had killed a fat hog with the movie and donations dropped drastically. Furthermore, the world indeed was beating a path to the Boys Town door, across its grass and flowers and saplings. Movie crews, the extras, the actors, and the sightseers dropping in to watch had done more than $5,000 in damage to Boys Town landscaping and property.

Enter again the man in the white hat on the white horse, the ubiquitous Henry Monsky, by now a national leader in his faith. He talked with MGM. It issued a statement clarifying the meager Boys Town gain and asking the public to continue contributing. It also agreed to pay Boys Town $100,000 to make a sequel about Boys Town.

The sequels were filmed but one never made it to the silver screen. Bobs Watson, the nine-year-old who played the pint-sized Pee Wee to Rooney, was impressed by what he had seen at Boys Town. When he dropped acting as a fairly young man, he felt a personal dissatisfaction in his life and became a Methodist minister.

The lever moving him into the cleric life was his remembrance of making the movie "Boys Town" with Father Flanagan. Watson wrote in 1996:

"I can still see him…talking to a group of important movie moguls…it is a hot, bright day…one of his boys, a little guy about my size, runs up behind him and stops…now his little hand is reaching up and gently tugging on the back of Father Flanagan's coat. The priest is turning his head. He sees the boy, then does a total about-face, turning his back on the important movie moguls as he kneels to the level of his boy."

Watson returned to Boys Town many times and served during the dedication of the new $2.5 million Chambers Protestant Chapel in the 1980s. He remained in close touch with all Boys Town directors until his death of cancer in 1999.

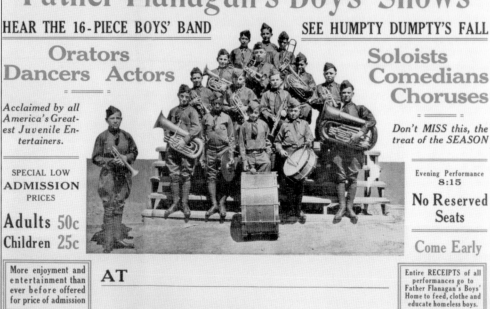

Coming! TWO HOURS OF ENJOYMENT Coming!
Father Flanagan's Boys' Shows

HEAR THE 16-PIECE BOYS' BAND　　　**SEE HUMPTY DUMPTY'S FALL**

Orators
Dancers　Actors

Acclaimed by all America's Greatest Juvenile Entertainers.

SPECIAL LOW
ADMISSION
PRICES

Adults 50c
Children 25c

Soloists
Comedians
Choruses

Don't MISS this, the treat of the SEASON

Evening Performance
8:15

No Reserved Seats

Come Early

More enjoyment and entertainment than ever before offered for price of admission

AT _____

Entire RECEIPTS of all performances go to Father Flanagan's Boys' Home to feed, clothe and educate homeless boys.

Everybody pitched in to get one of the Boys Town shows on the road. The above flier is the kind of poster the print shop turned out to precede the show. All travel was done by train or bus after the ill-fated horse-and-wagon show of 1922.

The shows were of varied nature, although the accent was on comedy and humor. The Mothers' Guild made nearly all of the costumes like the pictured clown's suit.

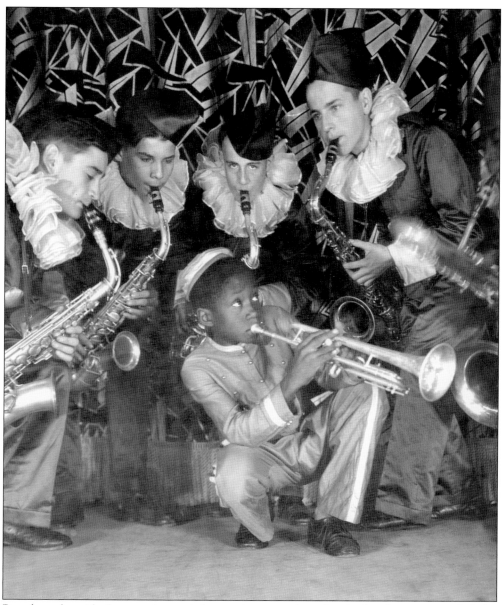

Boys brought with them to the road shows whatever talent they had and every group left the home with a different repertoire. One year, as shown above, the band was made up almost entirely of saxophones. The leaders usually had seven to ten years to develop talent. One lad in his time learned to play five instruments and became the headliner. The unexpected could be expected. One year, when the group was riding trains, Nebraska railroads refused to haul them for free. They got off in Council Bluffs, IA, rode a trolley to west Omaha, and were picked up there by the home's truck.

Oscar Flakes, portraying a drum major, was an extremely versatile member of the traveling show and one of its most popular for many years. Flakes died in 1990.

Colorful and exciting as it all had been, the end was in sight for the "world's greatest juvenile performers." By 1940, the radio and movies were very popular. The troupe sang its swan song in 1939 with the biggest show ever, a western extravaganza. It started early that summer in Fremont, NE, shown below. But there were no more 1,500-ticket sales. The show folded that fall, never more to leave Boys Town as a traveling variety show.

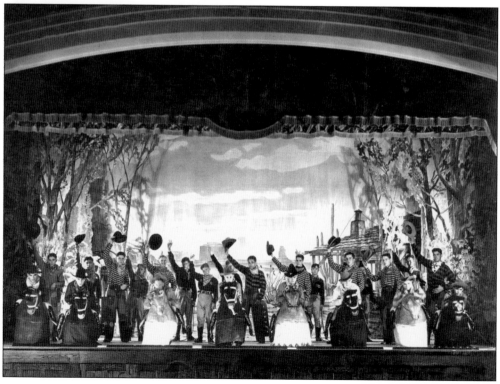

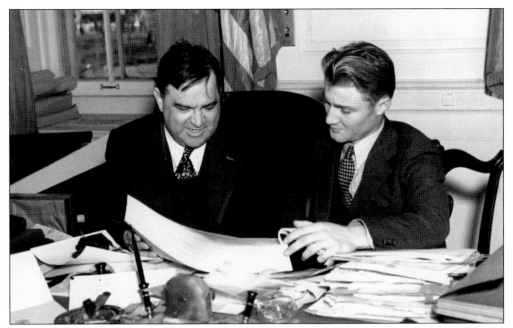

To encourage citizenship and self-determination, elections were re-instituted in 1935 and captured the imagination of the public. The elected mayor appointed officials who participated in making decisions about the dorms. Mayor Dan Kampan, above, was invited to visit the popular Little Flower, New York City mayor Fiorello LaGuardia, in 1936. That also was the year Boys Town became a village.

Will Rogers was elected national president of the Gloomkillers Club. He is shown here at center, meeting the Gloomkiller of the time, Miles Martin, and Father Flanagan. The Gloomkiller idea with its optimistic message probably indicates early the Flanagan flair for picking up what caught the popular ear and eye.

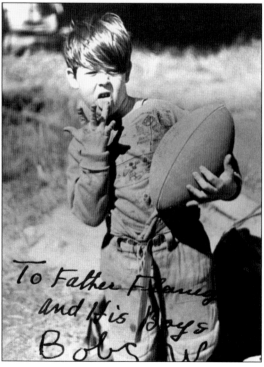

The 1938 movie, "Boys Town," spawned a long relationship between child actor Bobs Watson, PeeWee in the film, Father Flanagan, and Boys Town. They are shown here during the filming, which began a 50-year communication between home and actor. Boys Town got only $5,000 for helping in the first movie but a later sequel netted $100,000.

To Father Flanagan and His Boys
Bobs W.

This is one of his own photos that Watson years later sent to Boys Town. In his memories before his death in 1999, Watson credited his experience with the priest at Boys Town for directing him in later life to become a minister.

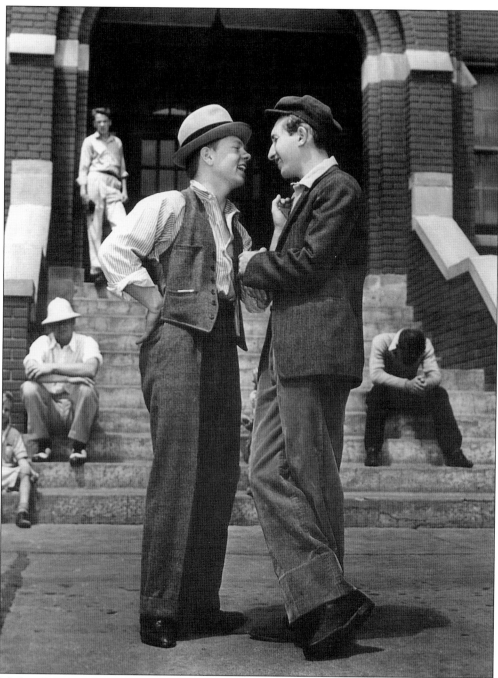

Mickey Rooney, the tough guy White Marsh in the film, here goofs off with co-actor Sidney Miller, right. The two actually had some of the most moving scenes in the Academy Award winning film. In one, Rooney gives Miller a black eye. Like Watson, Rooney has kept in contact with the home over the years. He and Watson both returned for the 75th anniversary of Boys Town in the 1990s.

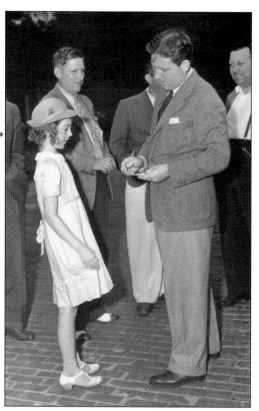

Spencer Tracy signs an autograph for a young admirer on the set in the photo at right. Tracy gave his Oscar to the home. Boys Town returned the honor many years later when Tracy's widow received the first Service to Youth award for her work with children with hearing problems.

Father Flanagan and Tracy, below, go over a scenario during a break in shooting. Tracy and Rooney were in the bloom of their acting careers at the time. About 50 years later, a reviewer looking back described the movie as sentimental but called it very well made.

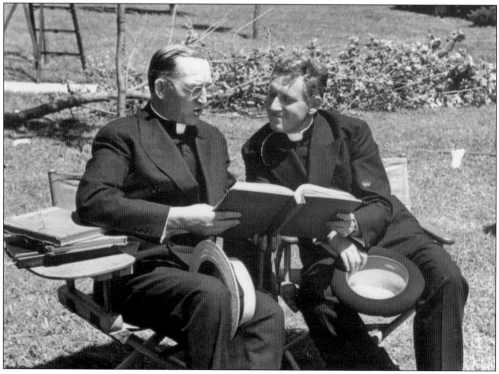

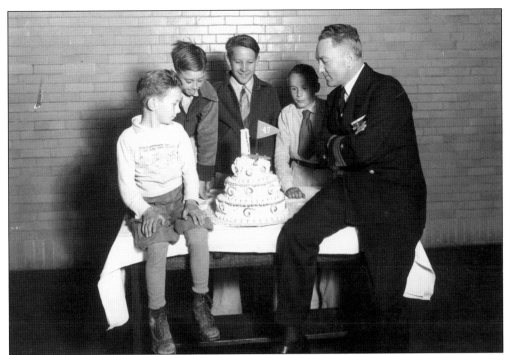

Explorer Richard E. Byrd was a frequent visitor to the home, the first occasion being in 1930, only a few months after monoxide poisoning almost killed him in the Antarctic. In October, 1935, he altered a speaking trip to be at Boys Town for his birthday celebration. He is shown here with some of the boys during the 1935 visit.

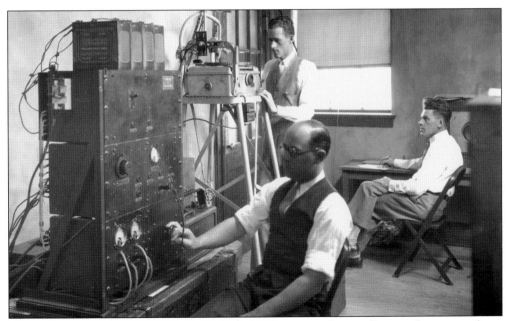

It was a new world of communication and everyone was taking a fling at the newest form, radio. Boys Town even had its own station, KRBT, for a time. This is the home's broadcasting apparatus being manned for going onto the air in 1930.

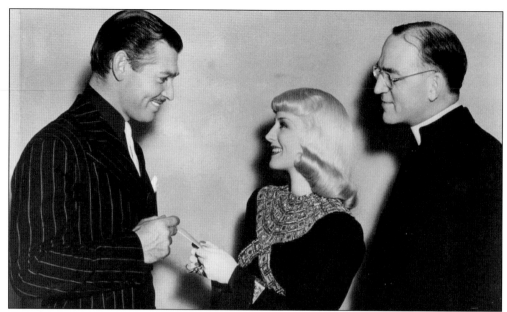

New doors were opened for Boys Town after the film in 1938. The name of the home wasn't foreign in the movie capital of Hollywood. The priest here is shown with movie stars Clark Gable and Norma Shearer, the first two to buy tickets to the football game between Boys Town and the Black Fox Military Academy of Los Angeles.

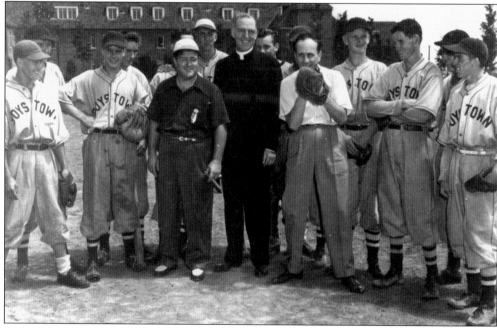

Comedians Lou Costello, the viewer's left of Father Flanagan, and Bud Abbott, at the right, delighted the Boys Town baseball team with their famous baseball routine when they visited in 1943. At this time, changes were coming for the center. The director already had ideas about dropping the 25-year old dormitory format for the cottages or individual homes which would embrace the home and family concept he was thinking about.

Five

THEIR WAY IN THE WORLD

What Happened with some Boys Towners

After Leaving the Home

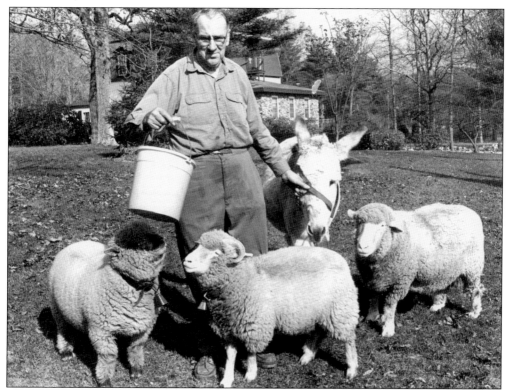

The gentle Brother Simon Long, feeding his flock at Benedictine Abbey, Hingham, MA, was known for his love for animals. The Boys Town graduate was found dead in a snowbank. The monk who as a boy wandered backroads aimlessly, was bringing in a newborn lamb to show brothers.

PASSING THE TORCH

As World War II began, the home discovered, the stories now were about the men of Boys Town.

Three graduates died in the first attack on Americans, a sizable loss for an institution so small. Killed in the bombing of Pearl Harbor on Dec. 7, 1941, were Donald Monroe, William Debbs, and George W. Thompson. Monroe, aboard the battleship the USS Arizona, may have been one of the first Americans killed in active combat during the war.

In all, more than 40 Boys Town boys were killed in World War II, 6 in the Korean War, and 17 in the Vietnam War. The numbers may be higher because early residents and the home frequently lost contact over the years.

A strange wartime interlude involved Father Flanagan and Japanese-Americans ordered out of their California homes by the government. After Pearl Harbor it was determined that Japanese-Americans, even Nisei or those born in the United States, might be a threat.

More than 100,000 were placed in internment camps, termed "America's concentration camps" by historians, with no legal redress. Father Flanagan, needing manpower at the home and feeling the sufferance of the Japanese-Americans offered several jobs.

Over the war years, an estimated 300 Japanese-Americans were aided by Boys Town. Some remained with Boys Town after the war. Two joined the famous Japanese-American 442nd Regimental Combat Team and were killed in action—while their relatives were held behind barbed wire in America.

Boys Town graduate Lloyd Bucher also was the central figure in another strange and torment-filled international drama, as Commander of the USS Pueblo early in January 1968. North Koreans captured the poorly-armed ship, claiming it was a spy ship, although it was in international waters.

Bucher and his crew were held for nearly a year, poorly treated, and tortured in an episode gaining world-wide attention.

Not all of the men of Boys Town were drawn into the high drama of the world. Many became priests and ministers. One graduate, Simon Long, became a monk in 1937 and in 1954, one of the founders of the Benedictine Abbey of Our Lady of Glastonbury at Hingham, MA.

It might be said that Father Flanagan was also subjected to war's indiscrimination between its active and passive participants. His health always marred by recurring ailments, he was asked by the government to travel to the Orient and consider and make recommendations on the youth and family problems of Japan and Korea after the war. It sapped him. That trip was

only a few months over when, in 1948, he made a similar trip to Europe, where a heart attack claimed him in Berlin.

Within four months, Monsignor Nicholas H. Wegner, diocesan chancellor, was named the second director of the home that started so modestly 31 years before. The move surprised because it passed over a priest who had been working with Father Flanagan and was assumed to succeed him. To calm those who feared radical changes, Monsignor Wegner issued a simple statement: "In the administration of Boys Town, I will try in every way to follow in the footsteps of its founder."

He did that. But this was not the gripping chore. The home owed $6 million. Furthermore, Father Flanagan, feeling the dormitory style of care must be altered, had begun building individual cottages. That task must be finished. He also had finally established a Boys Town trust fund. That had to be drawn to financial solvency.

Monsignor Wegner, known as a top administrator by observers, was the man to do it. Like his predecessor, he was born in 1898 into a large family of 12 children. The Wegners farmed near Humphrey, Nebraska. And like his predecessor, the second director also seemed headed for the priesthood early in life.

He was a promising young baseball pitcher when he turned down a Chicago Cubs contract in 1918. He continued to pitch semi-pro ball, using the money to pay his way through seminary. He was ordained in Rome in 1925.

The Wegner stewardship at Boys Town can be best described as building and strengthening. He emphasized athletics and vocational training. In his 25 years, a new high school, the career center, a dining hall, music hall, field house, and 25 cottages were built. At one time, the residency was nearly 800.

The Vocational Career Center was a jewel. In the 1960s, it was considered the finest in any secondary school, public or private, in the country. For many years, it provided vocational training for the public schools in the Omaha area. Boys Town agriculture and horticulture programs became known over the nation.

He continued the Flanagan open-to-all philosophy and in defense of the religious differences the home tolerated, he wrote, "Although Father Flanagan's Boys' Home was founded by a Catholic priest, we accept boys regardless of their creed or color…no boy under our care is obligated in any way, shape or form to become a Catholic."

The home in its funding campaign had begun mass mailings over the nation from address lists. Monsignor Wegner continued and broadened this program. Under him, in time Boys Town not only emerged from debt but built the trust Father Flanagan started into a sound source of income.

Questions on this were to come. The Wegner years became a golden age of expansion, arts, and sports.

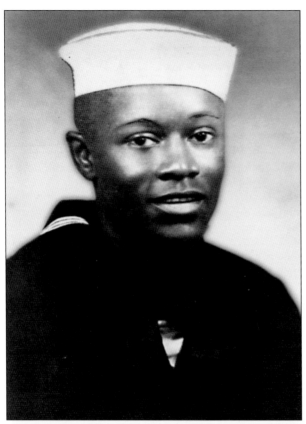

Boys Town's Donald Monroe may have been one of the first Americans killed in the nation's active participation in World War II. He went down on the *USS Arizona* in the first attack on Pearl Harbor on Dec. 7, 1941. The ship had seen the film "Boys Town" some time before the attack and Monroe wrote Father Flanagan that he told shipmates, "That was you, up and down."

Cecil Stoughton is shown here greeting Father Flanagan in Hawaii as the priest started his 1947 fact-finding mission to the Orient. Stoughton became a close friend of Father Flanagan when he was at Boys Town in the 1930s. The Air Force photographer was the White House photographer of President Kennedy. He took the famous photo of Lyndon B. Johnson being sworn in as president following the Kennedy assassination.

Rt. Rev. Msgr. Nicholas Wegner, Boys Town's second director, who is shown here umpiring a baseball game at the campus, not only was an avid sports fan but turned down two professional baseball contracts to enter the priesthood. He was considered an excellent pitching prospect.

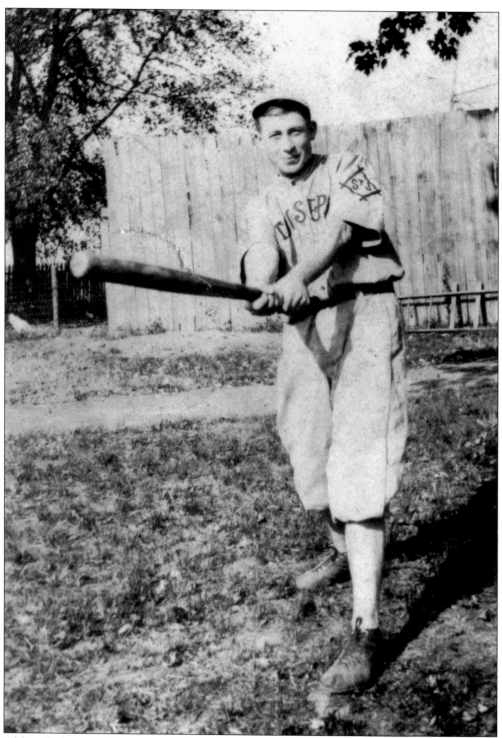

Although the second Boys Town director's baseball fame came as a pitcher, he is shown in this family portrait taking up the bat. Monsignor Wegner used the money he got for pitching games, usually $50 to $100, to pay his seminary costs.

The birthplace of Monsignor Wegner near Humphreys, NE, on a late, 1898 day. The first three directors of Boys Town all were born on a farm. All were born in July. And all were born into large families. Monsignor Wegner always was thought to be headed toward the priesthood.

This 1925 photo vividly portraying period dress was taken at the Wegner ordination in Rome of that year. With him are his mother, Christina, on the left, and his sister, Claire, on the right.

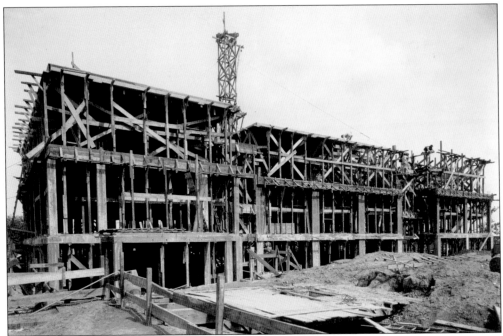

Old Main going up. This is a 1922 photo of the construction of the first Boys Town building. For several years, it served all purposes. The final temporary structures weren't removed until 1929.

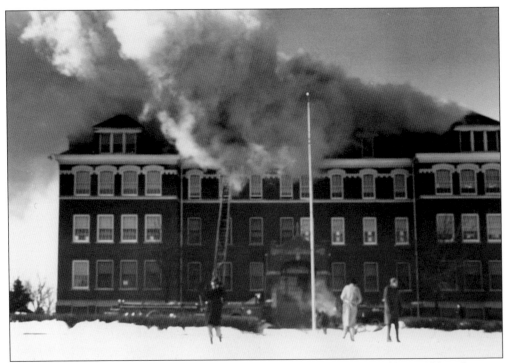

Old Main going down. This fire in 1947 caused serious damage to the building. Although it was repaired, it had to be entirely removed within a few years. The regular fire department fought this blaze, but in earlier years, bucket brigades manned by the boys themselves controlled the fires.

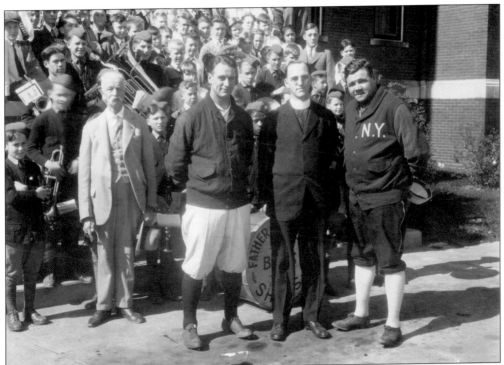

A lasting bond seems to have been forged between, from left, Lou Gehrig, Father Flanagan, and Babe Ruth. The baseball greats visited the home Oct. 15, 1927. Their New York Yankees were world champions, Ruth hit 60 home runs and Gehrig was the most valuable player. Gehrig was the product of a strong home and family, and Ruth was a Baltimore boy of the streets and industrial schools. They seemed to understand more than most what was at work at the home.

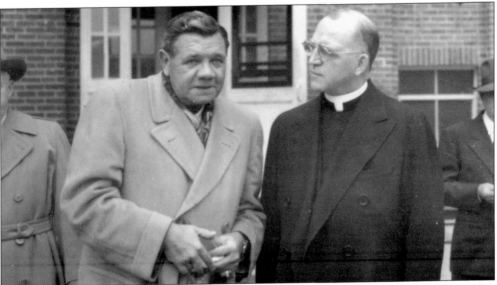

Ruth visited Boys Town three more times. The last was at his own insistence, in November 1947, when he knew he was dying of cancer and wished to see the home one more time. Ruth and the father are shown at their last visit together. Within a year both men would be dead.

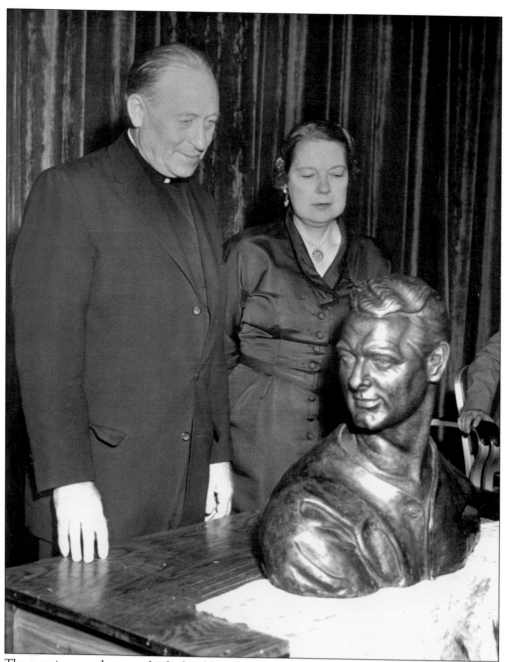

The curtain came down on this little tableaux from pre-war America on Sept. 21, 1955. Gehrig's widow, Eleanor, presented the bronze bust the Yankees had commissioned of the baseball great to Msgr. Nicholas Wegner and Boys Town. The bust and a baseball signed by all the Yankees of the 1927 team are still on display at the Boys Town Hall of History.

In this surrealistic image, two of the boys are shown etching in their metal work in the career center's machine shop.

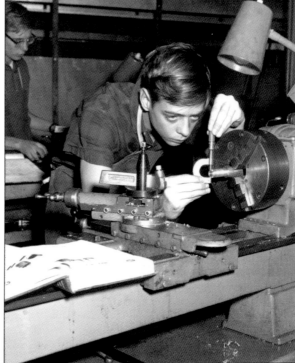

The machine shops, where this resident works with a micrometer, was considered the best in the area. In the 1970s, several public schools in eastern Nebraska were using the career center at Boys Town.

The Career Center would take on just about any job and sometimes it would almost get out of hand. In the case above, the shop undertook the renovation of an old Colorado mountain train engine into a highway-traveling vehicle. The train-truck highlighted parades for many years.

The Thanksgiving Day result of the culinary school at the center. Father Flanagan believed every boy should learn a craft. The career center he had planned was finished in 1948, the year of his death, and his predecessor, Father Wegner, put it into extensive service.

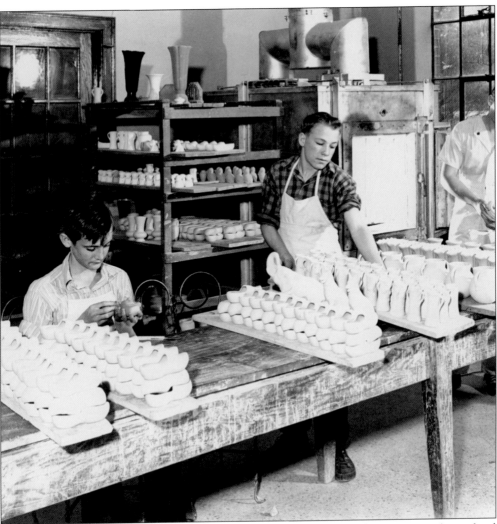

The ceramics workshop, pictured here, was at one time considered the most complete school ceramics center in the United States. For many years, their fires hardened the images of the Two Brothers that were sold across the nation. The fires in the kilns were banked many years ago.

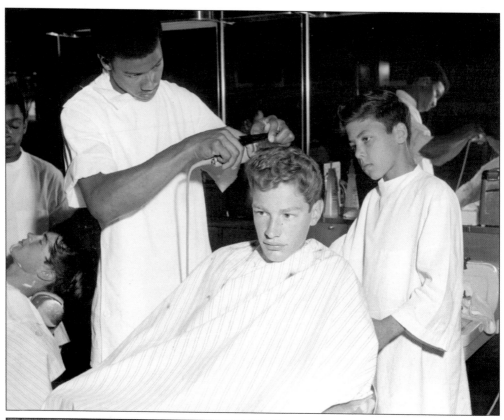

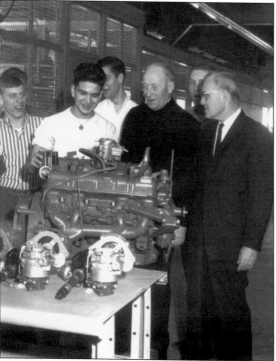

Barbering was popular at Boys Town. Father Flanagan felt it was a worthy occupation, and besides, it cut costs as well as hair. Barbering student Mel Richardson is cutting the hair of sophomore Jerry Conrad while a younger resident looks on.

Many programs other than athletics reached a zenith at Boys Town during the 25 years under Father Wegner. He is shown here looking over an automobile engine rebuilt by the center's shop in the 1950s.

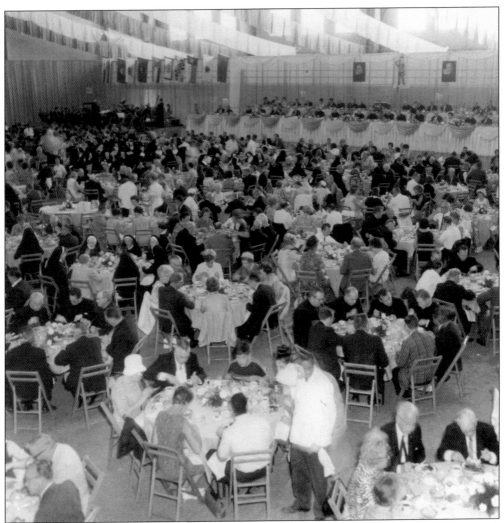

By the 1960s, Boys Town's alumni totals were up in the thousands. The alumni reunions and gatherings became very popular, as is shown in this one which filled Palrang Field House. As the years passed, Boys Town archivists began transcribing on tape accounts of some of the earliest residents, now grown into successful citizens. Many of the stories in Boys Town histories came from those taped accounts.

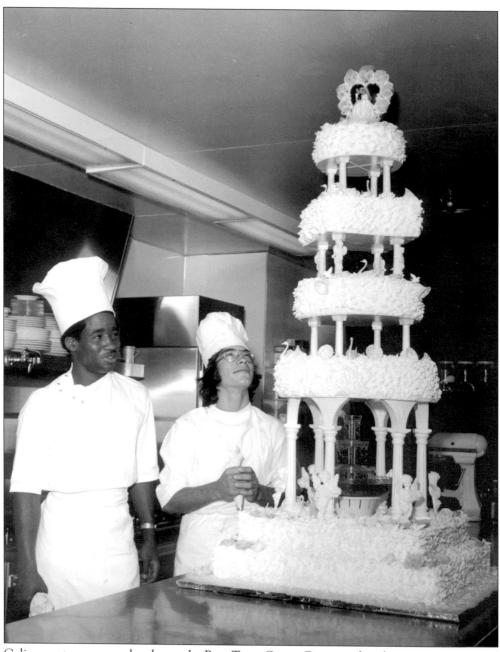

Culinary arts was a popular class at the Boys Town Career Center and students were encouraged to use imaginations, which resulted in this 6-foot tall, 120-pound wedding cake. The two students, Rufus Bragg, left, and Jerry Garcia spent 12 hours making it for the wedding of a Boys Town graduate friend in 1974 and the picture made newspapers nationally.

Six

SPREADING THE WORD

Entertainment, Sports

Radiated the Boys Town Spirit

Father Francis Schmitt, who directed the Boys Town Choir through more than three decades, worked long hours with the boys (above). The choir maintained a near-professional pace in its appearances and the priest remembered Christmas as an especially hectic time. For years, singer Helen Traubel and the choir brought in Christmas Day on one network.

A DESPAIR IN AFFLUENCE

In 1950, as the world concerned itself about a Cold War that sometimes turned hot, Americans coddled themselves in affluence they hadn't known for 20 years.

More families had homes, more families had one, then two cars, more families had one, then two television sets, and more kids were bound for college.

At Boys Town, Monsignor Wegner had broadened, updated, and modernized the annual mass appeals for funds. His administration began to whittle into the $6 million debt. The trust that Father Flanagan had established in 1941 was funded and began to grow.

The Boys Town farm now was an agriculture and agribusiness leader. The Career Center, in four clusters, offered training in 18 areas, and a scholarship program that permitted boys to continue their studies in their fields.

The days of the wandering show troupes was over and television was taking market from radio but the march to get the Boys Town message out scarcely missed a beat. The Boys Town founder a few years before his death had appointed two men instrumental in that.

Father Francis Schmitt, fresh from seminary, took over the old Boys Town Choir in 1941 and beefed it up to 80 voices. He was not to leave until 1974. By then, the choir would be known worldwide, traveling through the United States, Canada, the Orient, and Cuba. It sang at an international conclave of church choirs in the Vatican at Rome.

The choir made records and appeared on several national television programs. It became an early Christmas Day trademark, presenting a program of Christmas music directly after opera star Helen Traubel sang "Silent Night" at midnight. Many television shows emanated from Boys Town, including the Voice of America, and featured the choir.

The growing Boys Town Sacred Music Collection, started by Father Schmitt, made the home the site of a national workshop on sacred music every summer from 1953 to 1969.

A few years before Father Schmitt's death in 1994, the collection was given for display to Duquesne University in Pittsburgh, PA, By then, it consisted of more than 6,000 volumes, some of them rare hymnals.

Maurice H. "Skip" Palrang, of the Boston Irish Palrangs, already a successful high school and college coach, chucked it all to become a bureaucrat in 1941. That had lasted less than two years when Father Flanagan made him an offer he couldn't refuse—coach everything AND teach at his place, Boys Town.

Palrang remained from 1943 to his retirement in 1972. Basketball teams he coached won 240 games and lost only 95.

Football was the main course. For many years, Boys Town couldn't get regular Omaha metropolitan football games so the team went on the road, playing from Seattle to Washington D.C. to Miami.

They played many benefits and sponsors were happy to pick up the costs. They were a great draw, almost always playing before more people than colleges did at that time.

After all, you were going to see a good football team and you might also see the great Father Flanagan place kick a football.

Some of the first words in Palrang's briefing for teams going on a trip seemed to reflect the spirit of the boys:

"We are representing the finest institution of its kind in the country. Each one of us is a personal ambassador...any reflection on our deportment will be a black mark on Father Flanagan's ideals and accomplishments."

The winds of unpleasant change were blowing across the land. Boys Town and other agencies and institutions were confronted by difficult challenges. The youth who now arrived at Boys Town had histories of drug problems, had tried suicide, experienced battering, sexual abuse, and neglect. Divorce numbers and substance abuse were growing. Families often were said to be dysfunctional, impaired, or incomplete as a working family unit.

At the same time, Monsignor Wegner had been struggling with health problems for more than a decade. Then he was faced with what might be called an indictment for success, rather than failure.

A local weekly newspaper published a March 1972 story about the growth of the Boys Town fund, more than $200 million by that time The public waited for another shoe to drop. When it didn't, when no scandal was revealed, a New York newspaper commented about Boys Town that "they are just successful at what they do and the money is going to good use."

Monsignor Wegner, pointing to the home's severe lack of funds in most of its early days, said that because of the success of the fund, "Boys Town will be here for years to come."

Even before the story, the Boys Town board of directors had commissioned a study to examine the role of Boys Town in the new litany of distress facing the young. It recommended expanding services and dropping dormitories entirely and going to more individualized care, among other things.

As a result, in 1972 the directors announced a $30 million program for an institute for the study and treatment of hearing and speech disorders in children. That today is the Boys Town National Research Hospital, near Creighton University in Omaha.

Monsignor Wegner, because of his health, retired in 1973. He remained in residence at Boys Town until his death in 1976.

He was succeeded by Father Robert P. Hupp at his retirement. The third Boys Town director was an ex-Navy chaplain, the founder of an Omaha parish and vicar general of the Omaha Archdiocese.

He recognized the problems of the new youth coming to Boys Town. Family life had wasted away in abuse, poverty, drugs, alcoholism, and divorce. Emotional and behavioral problems deepened by confrontational peer pressure hammered at the young.

He called them "social orphans."

The home's Music Hall, here serving as the backdrop for the choir, was part of the $30 million building program initiated in 1946 and completed following Father Flanagan's death. The home stage of the choir, it also has attracted many national and international artists over the years.

For 20 years, the Boys Town Summer Workshop was a highlight of the year, largely the result of Father Schmitt's collection of sacred music. It was an aid to choir members like these, receiving training background from guest organists and singers. The Schmitt collection of sacred music was donated to Duquesne University in Pittsburgh.

Friendly Boys Town-Japanese connections remained long after World War II, with a strong Japanese presence on the campus. In 1968, Father Schmitt and the choir made an extended tour of the islands. The members are shown here on bridge at a Japanese shrine.

The Boys Town Choir appeared on the Osmond Family's Super Kids television special in 1979 Choir alumnus Moe Szynskie had replaced Father Schmidt as director. By now, as a result of changes at the home, choir training was more difficult. Youth were at the home about 24 months. In the old day, the kids had been there as long as nine years.

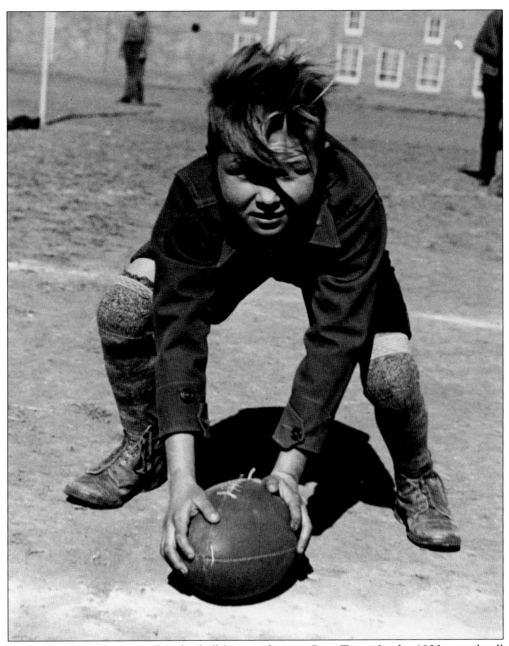

Baseball was the first sport but football became king at Boys Town. In the 1930s, nearly all played. The home maintained two separate teams until injuries altered that. As this lad shows, the uniforms were ragtag and the football scuffed, with the laces coming lose. But they played.

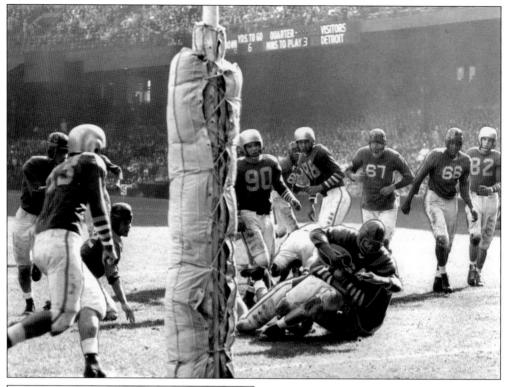

A Boys Towner, in the old fashioned helmet, slides near the goal line and the old padded goal post playing against Central Catholic of Detroit at Briggs Stadium before 35,000 in 1947. Competition between Boys Town and Aquinas High School of Rochester, NY, was fierce and in 1947, the difficulty of getting a ticket to the game was the subject of a national cartoon. The school played in the Orange Bowl in a Miami, FL, benefit in 1946.

His name was Maurice H. Palrang—Skip to all. He once stirred the sports world by asserting that baseball and basketball players needed to be gifted but anyone could be taught to play football—and made it stand. Palrang, who died in 1978, won 201 football games, lost 66, and tied 12 from 1943 to 1972, when he retired. And his teams played all kinds of competition.

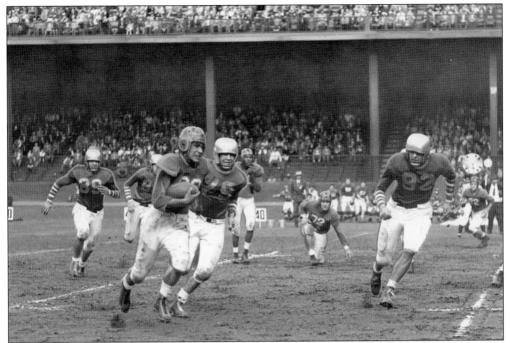

Palrang's 1946 team, 11 and 0, probably was one of the best high school teams in the nation, and had only one player over 180 pounds. One of the team's backs is shown above carrying the football. Boys Town teams under Palrang frequently played before packed houses of 40,000 spectators. He was a hard taskmaster both on and off the field. Before each trip, a ten-point list of demands for off-field deportment was first read, then given, to each player.

Football was part of the every-day life at Boys Town for many years, as the intensity of this modern-day pickup game shows. It was partly the result of on-field success but more, it fit the Flanagan philosophy of activity. He was concerned when he saw idle boys. If the priest spotted a bunch loitering around the front of a dormitory in the evening, the same dorm was sure to get a letter inquiring if its inhabitants didn't have enough to do. An old boy once said of Father Flanagan, "He seemed to think you should go to bed dog-tired every night."

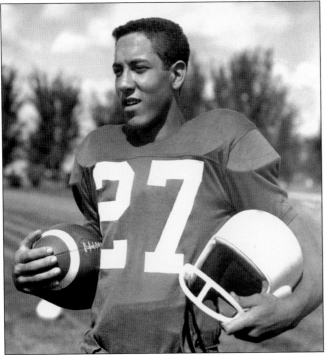

Charles (Deacon) Jones, looking over some of his trophies with Father Wegner, graduated from Boys Town in 1954 and became one of the country's great distance runners at Iowa. The personal best day for Jones, who ran in the 1960 Olympics, came at a Big Ten track meet when he won the mile race, then came back within 90 minutes to win the two mile.

Wilburn Hollis, a graduate of Boys Town in the 1950s, received a scholarship to Iowa University and became a second-team All-American, the highest ranking, to that point in time, of a black American quarterback.

These boys are setting the table for dinner in the Great Hall, part of the home's post-war building program. Most Boys Towners today eat at family gatherings in the individual homes.

Contrast this 1920s picture from the mess hall in the Old Main Buildings. Boys Town had come a long way. There were even more radical changes in the post-war future.

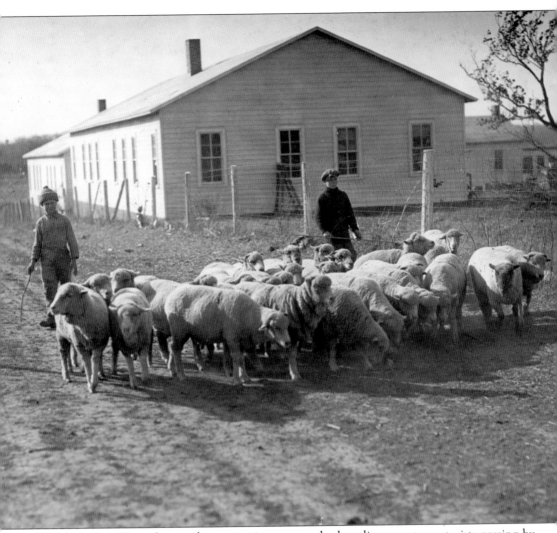

The lush Boys Town farm and its activities presented a bucolic scene to motorists passing by on the busy highway at the north end of the home. Here a young shepherd drives home his flock late in the afternoon of a 1950 fall day. Scenes like this were not to be repeated for long. The city was growing up around Boys Town. The world both outside and inside Boys town was warping and bending in a direction that would never permit it to return to the old days.

Seven

THE SEARCHING

Not Alone in a Wilderness

Father Hupp greets a new Family-Teacher couple and two boys at the first new home unit in 1976. Boys Town switched completely from its old dormitory style to the new home system within two years.

FAMILIES OF BOYS TOWN

By 1974, America seemed besieged by violent alienation. Turbulence in the home and tumult in the street served to disenfranchise the young of their childhood.

Newer, easy-to-get-drugs made their way to markets; alcohol consumption was up among teen-agers; the divorce rate was rising; family abuse stories were alarming; residuals of the Now Generation and its drug culture were found to be visited upon the very young.

The American family tradition seemed to be wandering in a wilderness, finding only wispy solutions. The way was not lonesome. An entire generation of care agencies born since the beginning of Boys Town in 1917 also groped for answers to new dilemmas. The old guides of love and safe harbor alone were not enough to mend fractured, young self-esteem.

In 1974, under Father Hupp, a new way was charted through the wilderness. Boys Town direction took a drastic swing: as Father Flanagan envisioned, it scrapped all its dormitories for group homes. Each would have eight to ten boys of all backgrounds. With them would live Family-Teachers. These trained and selected husband-and-wife teams would care for the boys 24 hours a day. Basically, Boys Town would continue to provide food, shelter, education, and vocational education under old interracial, inter-faith themes. From the home and the Family-Teachers, the boys would learn family and relationship building skills.

This was the fledgling ideal of Achievement Place at the University of Kansas in Lawrence, KS. The Family Teaching Model goal was to develop community-based, family style group home treatment for disadvantaged and delinquent youth. The methods should be effective, economic and open to adaptation by other programs. Boys Town, attracted by its research and development, became its standard bearer.

By the end of 1975, all Boys Town dormitories had been vacated and residents were in new family homes. The Family-Teachers used teaching skills designed to correct poor behavior and encourage positive behavior. Each home had a self-government system under which youths participated in decision-making.

Some said the idea wouldn't work in a center the size of Boys Town because it depended upon the training of the Family-Teachers and the ability of administrators to provide consultation and evaluation of them. Boys Town was able to make consultants available 24 hours a day. As for evaluation of Family-Teachers, Boys Town was able to provide ready communication between youth, parent or guardian, teacher, probation officer, and others involved in individual cases.

There were the boys of Boys Town, then the men of Boys Town. Now there would be the families of Boys Town.

Boys Town offered the system to other youth care organizations. Today, more than 100 affiliated family homes in 15 states use Boys Town technology.

Childhood problems may have physical causes. The Boys Town National Research Hospital leaped to the forefront in diagnosis, study, and treatment of speech, hearing, language, and learning impairments. By 1991, it was one of the first three national research and training centers in those disorders. The others were Johns Hopkins University in Baltimore and the University of Iowa.

The Kansas plan had proved safe, effective, and family-oriented at Boys Town. Now it was time to see if it could be duplicated elsewhere. In 1984, under the banner of Boys Town, U.S.A., the first Boys Town was opened in Tallahassee, FL.

Five years before, something else happened that was little noted off the campus. Boys Town since 1977 had been treating girls with communications disorders but residential care was limited to boys. Father Hupp had found himself responding to questions about when the home would begin taking girls. As an official of the Good Shepherd Home for troubled girls, Father Hupp was aware of the growing problems among young American girls. In 1979, Boys Town accepted five girls who eventually began to live on campus. The number reached 26 by 1985.

Father Hupp recalled that the move was first considered a mistake but "it actually improved the behavior of the boys."

There were false starts. Under Monsignor Wegner, Boys Town had agreed to a $40 million youth development study with several colleges. It later was decided this wasn't what was needed and several years and several million dollars later it was dropped.

Also inaugurated under Father Hupp, in honor of the Boys Town founder, was the Father Flanagan Service to Youth Award. The first named in 1975 was Mrs. Spencer Tracy for her work with hearing-impaired children. Others over the years included Mother Teresa of Calcutta; comedian Bob Hope; basketball players Julius Erving and Michael Jordan; and Jonas Salk, inventor of the polio vaccine.

Another barometer of trouble among youth in the 1970s was the growing number of students expelled or suspended or who simply dropped out of schools. Boys Town set sights on this problem and financed and staffed Father Flanagan High School in Omaha's inner city. The $11 million school opened in 1983, offering the standard curriculum and self-discipline and parenting classes as well as day-care for young mothers seeking to finish their high school educations.

Boys Town was entering disciplines of child care far beyond the tender environs of that house on a hill in Omaha in 1917.

And now there were the girls of Boys Town.

In 1985, as the alternative education of Father Flanagan High School geared up, as the novelty of girls on campus subsided, Father Hupp reached retirement. His successor was former Creighton University faculty member, Father Val Peter.

Father Peter called his predecessor a great builder who came at a time when child care was in "great disarray." Then he set out to broaden the Boys Town model and bring it into other communities.

Always a tourist draw at the Leon Myers Stamp Center is the 600-pound ball of stamps, shown here in 1972 with employees Violet Unger, Wren Culkin, and Mel Stark, from left. Put together by boys in the home in the 1940s and 1950s, it is made up of more than 4.6 million cancelled stamps from donations. Boys Town annually attracts more than 100,000 visitors.

By the time of Father Hupp's retirement there was a new presence on the campus. The first five girls had graduated from the high school in 1983. Soon a girl would be elected mayor. Boys Town shortly would be involved in the biggest expansion of its history.

Boys Town drifted slowly but surely toward accepting girls on campus during the 1970s. This is a picture of a coed tug-of-war match during the Boys Town-Girls Club picnic in 1976. Five girls were accepted the following year on an experimental basis but weren't lodged on campus.

When Ernie Holmes became a Boys Town friend and donated a pool table in the 1920s, ladies were not allowed in pool halls. The customs changed much over 80 years. These two boys are showing two new Boys Town girls how the game is played.

The Boys Town National Hotline telephones provide information and service to 250,000 children and parents a year. The trained counselor in the photo has access to computers linking her with more 20,000 child care agencies across the nation. The center is manned all the time.

An atrium at Father Flanagan High School was a student gathering place during classes. The school offered a chance for borderline and dropout students to return for a high school diploma but was closed in 1997 after passage of a new law. It had been open only 14 years. The building later became the Omaha Boys and Girls Clubs.

First called the Boys Town Institute, the National Research Hospital quickly became one of the nation's resource flagships in identifying and treating learning disabilities. A specialist here works with a young patient collating the image of numbers in the mind by sight and sound.

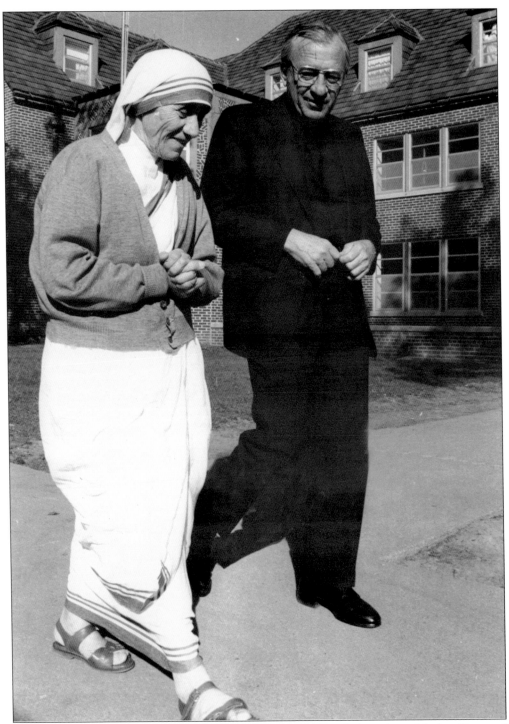

One of the first to receive the Father Flanagan Service to Youth Award was Mother Teresa of Calcutta, long noted for her work among the economically ravaged cities of the East and its impoverished humanity. She came to Boys Town to visit with Father Hupp in May 1976 when she received the award.

Eight

THE NEW CENTURY

New Faces, New Images,

but the Flanagan Spirit Remains

This is the dedication in 1994 of the Boys Town U.S.A. Las Vegas, NV, Shelter, a temporary care center near the downtown area. Group homes for longer stays also were completed in 1991. Boys Town of Las Vegas in 1999 assisted 428 children. The organization also has programs in 18 cities including New Orleans, LA; New York City; Ovieto and Tallahassee, FL; San Antonio, TX; Washington D.C.; and Los Angeles, CA.

"You Should be Nationwide"

A casual look about the entrance of Boys Town, NE, quickly establishes the quintessence of its unique founder. There is, of course, the statue of the Two Brothers and its familiar: "He ain't heavy, Father, he's m' brother."

Behind the statuary at the entrance is the Garden of the Bible, flanked on the east by Catholic Dowd Chapel. To the west is the Protestant church, Chambers Chapel. Through the shaded verdancy of its trees, shrubs, and grass walk clusters of boys and girls of all ethnic backgrounds.

It bespeaks the ideals of love, brotherhood, and open society of Father Edward J. Flanagan. All this was not lost on California insurance executive Leon Myers, a perennial benefactor of Boys Town, in July 1989. The occasion was the renaming of the noted philamatic center to become the Leon Myers Stamp Center. Myers said he had been asked many times why he gave so much to Boys Town.

"Your Boys Town strikes a chord that no other charity can match. You bring out the best in America, the concept of helping and supporting young people…the need is national. You should be nationwide."

This, in turn, was not lost on the current director, Father Val Peter, who was present that day. Father Peter is a native Omahan and has grown up on the Flanagan and Boys Town spirit.

A goal when he became director in 1985 was to keep to the kindling point the Flanagan spirit. Another was to move Boys Town to an expanded national status with expanded care.

Father Flanagan started getting the message out with boys in parade in Pilgrim costumes, singing and dancing on every stage in every small town he could get to and getting there in wagons pulled by horses. Father Peter had better weapons.

He turned loose the resources of the modern Boys Town, triggering an evangelism the founder could not have imagined.

A program designed to encompass the efforts of establishments in 17 major metropolitan areas by 1993. And it had been learned that it was not necessarily desirable to move all children from their homes for long periods. Under an umbrella called Family Based Programs, services for parenting, foster care, and family preservation were initiated.

By 1989, telephone lines were active into the sophisticated Boys Town National Hotline 24 hours a day, seven days a week. Trained counselors took calls from over the nation, offering expert advise or information on where to get it. Today, the hotline answers nearly 250,000 calls a year, according to the manager, Ginny Gohr.

120

There were changes at home. The Garden of the Bible was laid out in 1991. The home was named to the National Registry of Historic Places. Father Peter expanded the enrollment of girls to fully 50 percent of the Boys Town population. A Boys Town Hall of History was founded, partly as a result of a man who had never seen Boys Town. When wealthy Chicagoan Henry J. Hess died, about a fourth of his $3.3 million estate was left to Boys Town and some of the funds were used to build the hall.

All problems weren't avoided. Nebraska passed a new law requiring all school districts to operate alternative education programs similar to that of Flanagan High School. That could result in a duplication of programs and Father Peter felt this would make Flanagan High surplus. In 1997, it was closed and sold to the Omaha Boys and Girls Clubs.

By the end of the century, the organization had centers offering a wide variety of assistance at 18 locations across the United States. The aid ranged from:

—Long-term residential care at group homes under the family-teaching regime patterned after that in the home base at Boys Town, NE.

—Short-term residential, or shelter, care in a safe environment.

—In-home counseling and background for the preservation of families and the development of common-sense parenting.

—A foster-family network that provides 24-hour a day support and evaluation from the central staff.

—Information and advice from the National Resource and Training Center and the diagnostic and research capabilities of the Boys Town National Research Hospital.

Boys Town now offered as much assistance to girls of America as it did to the boys. In April, 2000, the board of directors met to take up an issue often discussed: adding girls to the name to reflect the extension of the old home's influence since 1917. At the August election of long-term residents across the country, adoption of the name Girls and Boys Town was approved by about 68 percent.

Also adopted was a new visual trademark. The picture of a girl carrying a younger girl was added to the logo of the Two Brothers, the famous Boys Town standard for more than 50 years.

The new name refers to all sites across the nation and the programs within them. Remaining under the old name are the Village of Boys Town and its fire and police departments, high school, research hospital, and national hotline. Road maps will list Boys Town, NE.

And the oldest name of all, Father Flanagan's Boys' Home, will remain to perpetuate the name and the dream of the priest who started it.

Will there ever be another Boys Town? For one thing, said Father Peter, the trials and triumphs of early Boys Town stirred the romance of the times and the times have changed. For another, starting costs would be too high.

"It's not realistic," said director Peter. "We might some day see another organization that wants to become part of it."

A former boy of Boys Town, Father Clifford Stevens has written about the impact of the home and its founder. Father Flanagan, he said, made the image of the homeless boy respectable as "a citizen in a state of formation but already possessing dignity and rights." He said Father Flanagan struggled against the facelessness of institutionalization, reversing existing concepts and Boys Town "quickly became a symbol of a new concept in education."

Father Stevens concluded: "He labored to preserve for Boys Town and every individual boy a sense of identity. In doing so his City of Little Men became a unique addition to the legend of America."

More history was made at Boys Town in 1991 when the first girl, Sarah Williamson, was elected mayor. The story and her picture appeared nationally. On a trip to Chicago, IL, for a television show, she was recognized by all. Sarah today still is on the staff at Boys Town.

John Real and his wife, Barbara, have been Family-Teachers at the home for several years. John is shown here carving the traditional Thanksgiving Day Turkey. As part of family teachings, Girls and Boys Town prominently accent the holidays.

Father Peter swears in new Boys Town residents, maintaining the early Flanagan emphasis on citizenship. The movie "Boys Town" focused attention upon the Boys Town Court, made up of youth officials who meted out punishment to transgressors. A common penalty in early days was to make the offender site with his back to the weekly movies.

Cadets usually ride along on real calls and are shown here entering a smoky building during training in Omaha. The village department today is part of a mutual aid pact involving about 20 communities around Omaha and all departments now have women members.

The fire cadets provide an honor guard at an observance at Boys Town. The gradual emergence of the girls of Boys Town into their own worlds prompted the board of directors to begin examining whether the Boys Town name should be expanded to include girls in May 2000.

A fire department was established soon after Boys Town became a village. In line with the founder's belief that the young should participate in local government, a fire cadet's corp has been formed. The high schooler above is getting ready to take part in a drill.

Halloween, as this picture shows, is a big event at the houses of Boys Town. On the other hand, Christmas Day has diminished from the early days, when all boys remained at the home. Today, under modern care guidelines, Boys Town has an early Christmas at the family-teaching home. Then the boys and girls, if possible, celebrate Christmas Day with their families.

Girls have joined the old tradition of bringing in the fall pumpkins at Girls and Boys Town. The farm at the old home no longer has the reputation it had for decades but it still grows a large crop of pumpkins in the fall. Very little of the food actually grown at the home today is consumed at the houses and cottages.

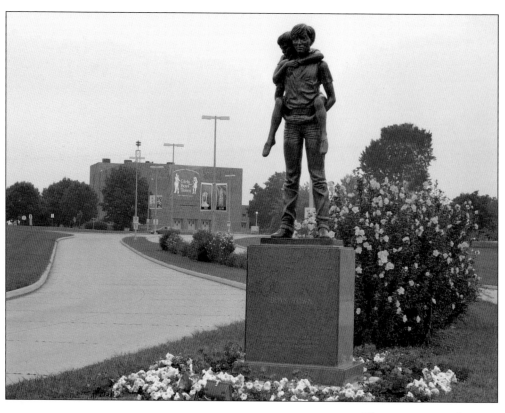

The entrance to what is today Girls and Boys Town. A half-century after his death, the impact of Father Flanagan still is visible about the campus.

The Original Father Flanagan's Boys' Home

Girls *and* Boys Town

HELP • HEALING • HOPE

The new logo for Girls and Boys Town reflects the presence of girls at the historic campus. It replaces a trademark known to millions over the past three generations.